ALSO BY JANET MALCOLM

STILL PICTURES

STILL PICTURES

On Photography and Memory

Janet Malcolm

With an introduction by Ian Frazier and an
afterword by Anne Malcolm

Farrar, Straus and Giroux
New York

Farrar, Straus and Giroux
120 Broadway, New York 10271

Printed in the United States of America
First edition, 2023

"Roses and Peonies," "The Girl in the Train," "Klara," "Jiřina and
Hanka," "Slečna," and "Daddy" originally appeared in the October 29,
2018, issue of *The New Yorker* under the title "Six Glimpses of the
Past." "Lovesick" originally appeared in the April 9, 2020, issue of
The New York Review of Books. "Sam Chwat" originally appeared in the
September 24, 2020, issue of *The New York Review of Books* under
the title "A Second Chance." "A Work of Art" originally appeared
in the July 19, 2018, issue of *The New York Review of Books.*

Photograph of Slečna Vaňková by Marjory Collins / courtesy of the
Library of Congress. All other photographs are courtesy of the author.

Library of Congress Cataloging-in-Publication Data
Names: Malcolm, Janet, author.
Title: Still pictures : on photography and memory / Janet Malcolm
Description: First edition. | New York : Farrar, Straus and Giroux, 2023.
Identifiers: LCCN 2022041023 | ISBN 9780374605131 (hardcover)
Subjects: LCSH: Malcolm, Janet. | Women journalists—United
 States—Biography. | Journalists—United States—Biography. |
 Women critics—United States—Biography.
Classification: LCC PN4874.M1965 A3 2023 | DDC 070.92—
 dc23/eng/20220923
LC record available at https://lccn.loc.gov/2022041023

www.fsgbooks.com
www.twitter.com/fsgbooks • www.facebook.com/fsgbooks

10 9 8 7 6 5 4 3 2 1

Contents

Introduction

BY IAN FRAZIER

The first photo of herself that Janet Malcolm includes in this book shows her at the age of two or three wearing a hat and a sunsuit and sitting on a stone step. She writes that she doesn't identify with the child in the photo or think of the child as herself. The viewer who is also the reader has a different reaction. The little girl is obviously a person for whom the world will be grateful in her grown-up life—a future *personage* whose extraordinary nature the camera has caught in early childhood. Even without that aspect of prophecy, the photo arrests us because the little girl is adorable.

Janet Malcolm wrote nonfiction like no one else, won a wide and devoted readership, knew the stark difference between delight and whatever isn't delight, and made some people angry with the straightforwardness and occasional asperity of her work. After she and I became friends, and I'd noticed that picture among others on the wall in her apartment, I saw that small personage as a still-surviving part of her. I adored her and told her so not long before she died. Coming home on the train, I kept wincing at having blurted such a risky and uncool thing, and I even wince a little describing it now. But I'm also glad I said it because it's true, and I imagine her accepting it for that reason, and not seeing it as too over the top.

As I'm writing this, her death is about ten weeks in the past, so I probably don't have the distance one would hope for in surveying anybody's work. On a Friday, I was talking to her on the phone, as we'd done many times over the twelve years of our friendship (if we didn't talk, we exchanged emails almost every day), and a few days later, on a Wednesday, she was gone. My sense of carrying on an interrupted conversation with my suddenly absent friend remains so strong, it makes me believe even more that something must exist beyond death. E. B. White once said that a writer writes until he dies. In my now one-sided conversation with Janet, I'm wondering if the writer (in this case, she) stops even then. She had good ideas for pieces whose energy may still be carrying her along, wherever she is in time-space or space-time, thinking about them. For thirty or forty years she listened to the same classical music program on a New York City radio station, with the same host, a woman. She liked the host, had learned some details of her personality over the years, and came up with the idea of writing a profile of this person without saying (or even trying to find out) what the person looked like. The point would be to fit the profile within the pandemic's imposed conditions of apartness; she would concentrate entirely on the voice, maybe filled in with some reportorial phone calls. As Janet got sicker and could not do much except lie on the couch, she told me she had thoughts about helplessness, solitude, and the end of life that could make another good piece. I could see that the piece already existed in roughed-out form in her mind, full of possibility. She never wrote it, or even made notes for it, as far as I know. But I believe the piece still exists somewhere and is somehow ongoing.

In this book are the last pieces Janet gave us. They exist outside of any simple category. She distrusted biography as a form and had a lot of skepticism about autobiography. In *The New York Review of Books* in 2010 she published a short piece in which she listed a few of the hazards involved in writing about oneself, such as the desire to seem like an interesting person, or the conflict between self-love and journalistic objectivity.

She also happened to be a good visual artist and knew about photography from her own experience of taking photos. She and I used to send each other pictures of so-called weeds. She did not believe in the concept of weeds, and supported me in my maintaining a bad—that is, weed-filled—lawn in the suburb where I live. Her photos of weeds looked wild and raucous and fabulous. Mine looked like weeds. Recently I read about a gardener who said how horrible burdock is. Burdock is the large-leafed, disturbed-earth plant whose burr-covered seedpods often end up in your dog's hair and seem to have provided the structural model for the coronavirus. Janet took hundreds of photos of burdock leaves—they get eaten by insects, and decay interestingly, and suggest other beleaguered leaves: ancient or recent manuscript pages, for instance—and she made a book of twenty-nine of the photos, called *Burdock*. In a short introduction she said she was trying to portray individual burdock leaves as clearly and as cruelly as Richard Avedon photographed individual human beings. Her effort succeeded; each burdock leaf is a life, seen straight on, epic and battered and dignified.

The main visual form she worked in was the collage. Among the hundreds of collages she made, some appeared in

gallery shows in New York, and now hang on collectors' walls. She also loved assembling bookmarks, her favorite kind of collage. I have fifty or seventy bookmarks she made and sent me. I use her bookmarks in most books I read, which means that now I can't find them all. In some future century, one or two of Janet's bookmarks will fall out from between a book's pages in the shop of an antique-book dealer and amaze their re-discoverer. The bookmark collages bring together papers from her father's psychiatric practice, Chinese Communist propaganda leaflets, Soviet hotel DO NOT DISTURB signs, strange newspaper clippings, World War II ration stamps, Muybridge motion-capture photo sequences, reproductions of classic paintings, her grade-school report cards. . . . She color-xeroxed the components and reduced them to bookmark size and fit them together. As readers of this collection will observe, she had a knack for choosing which ephemera to save.

She didn't describe the pieces in this collection as memoirs or autobiographical sketches; I recall her referring to them only by topic. Whatever they're called, she came to them through photographs, by way of her visual-artist side. That approach freed her. I had read all the pieces before seeing them assembled here, and on rereading, I'm surprised and sometimes saddened by what I'd missed. Her description of her family escaping the Nazis like insects who happened to avoid the insect spray rattled me, but now I see how deeply she meant and felt the horror of the image. Their wartime experience never gave her family psychological peace. Her second husband, Gardner Botsford, who went ashore on D-Day, also was in a unit that liberated a concentration camp. He never talked about that experience, nor did he include it in the book in which he tells

other parts of his war service. When he became Janet's editor at *The New Yorker*, her work opened out dramatically. I knew Gardner as an elegant and gallant man and a careful, intuitive editor. She may have seen him, at an emotional level, as her heroic American rescuer.

I admired the brilliant humor that ran through her life and work, but I hadn't understood it for the bedrock it was. Her sense of what was funny and her love of being a smart aleck exist in early form even in the photo of her sitting on the step. In one of these pieces, she describes telling her aunt and uncle and cousin every dirty joke she knew while on a car trip when she was a teenager. I was a smart-aleck teen myself, but telling dirty jokes to my uncle and aunt would have been a stretch, and I'm in awe of her dedication. At the University of Michigan, she and her first husband, Donald Malcolm, wrote for a humor magazine called *Gargoyle*. I have three issues of it, from 1952 and 1953, that Janet gave me. She contributed pieces with titles like "The Bobsey Twins Meet Ezra Pound" that hilariously mash-up high culture and low—in this case, the girl-detective mystery genre and early Modernist poetry. When she sends ironical letters from Ann Arbor to her lonely mother, her father pleads with her to have mercy and write her something that's "non-Gargoylian." Janet later thinks she was a jerk for ignoring him. I don't; mercy is too much to expect from a college kid who's into being funny. In these pieces, her disquisition on the Czech humor of her family's immigrant community separates that humor into horribly clunky and overbearing and unfunny, on one side, and playful and dangerous, on the other. The second is thrilling to her, the first almost beneath contempt. Her lifelong humor

derived from and Americanized the Dadaist, absurd, playful-dangerous humor of the Czech avant-garde. In short, as she says several times, she liked to horse around. To understand her work, you have to know that deep down or on the surface, it usually contains some horsing around.

She wrote these pieces at a level of wisdom that took a lifetime to attain, and that almost nobody reaches at any age. Maybe the most famous opening statement in literature, "All happy families are alike," from *Anna Karenina*, has always puzzled me because, first, *are* all happy families alike? (All Gaul wasn't necessarily divided into just three parts, either.) Second, how are all happy families alike? Here Janet comes to Tolstoy's aid. In a piece about her grandmother, Janet says that although she (Janet) and her sister disdained most of their elders' jokes, they believed their own family's humor "was of the highest quality." Then she adds, "All happy families are alike in the illusion of superiority their children touchingly harbor." The wisdom of this floored me. I grew up in that exact illusion and would not begin to question it until after I became eligible for Medicare. Janet's aperçu ended it forever.

Another great sentence, from her piece about her Czech teacher, Slečna:

> Sites of idleness and wasted time like the Czech
> school are fertile breeding grounds for the habit many
> of us form in childhood of always being in love with
> somebody.

Those sites are out there, all over the country: high-school study halls, empty theaters before play rehearsals, gym bleachers before practice, rec centers, small-town libraries. Kids

spend hours in them, dreamily, hopelessly in love. A page or two later she follows the observation with another, even more profound, about herself and her fellow classmates

> who secretly loved and, unbeknownst to ourselves, were grateful for the safety of not being loved in re- turn. The pleasure and terror of that would come later.

I can remember the moment in my life when I became aware of that romantic safety, on the one hand, and the plea- sure and terror of reality, on the other; lots of people, especially artists, get such mileage out of the first that they never ven- ture the second. But life brings everybody around, whether you're willing or not, and the pleasure and terror do eventu- ally come.

Describing the rituals at the Christian (Congregational) summer camp she and her sister attended as kids, she says she remembers the faux Native American camp motto, and the grace the whole assembly prayed before meals, better than she remembers most relics of her childhood. She liked the camp's religious intonations, and adds,

> Children are mystical-minded creatures; they sense the strangeness of it all. As we settle into earthly life, this sense fades.

It did not fade for her. Earthly life, as she experienced it, contained numinous effects, otherworldly manifestations, and sanctified figures like her neurologist-psychiatrist father, whom she calls "the gentlest of men." The fact that I'm a Christian and go to church interested her. The doings of the Episcopal

church I attend provided a recurring topic in our conversations. A few years ago, our minister's husband needed a lung transplant, and the theological-ethical question arose: Do we pray that a healthy pair of lungs becomes available? That is, do we pray for an organ donor to get in a fatal accident that leaves the lungs intact? And, if possible, soon? The question engaged Janet's philosophical and spiritual sides. Everybody was relieved when some lungs were found (I'm not sure how), the patient returned to health, and we left the conundrum behind.

Janet's parents sent her and her sister to a Lutheran Sunday school, part of the protective coloration the family assumed in their new country. She knew about regular churchgoing. I attended the eight o'clock Sunday morning service at my church, and being able to tell her about it afterward was one reason I went. (The eight o'clock is its own kind of contemplative service, and we who get up for it tend to be an off-brand subset of Episcopalians.) Sometimes I told her what the week's scriptural readings had been, and she looked them up and we discussed them. She enjoyed the scriptures as writing, and as texts to ponder. Sometimes she said she wished she could believe, but just couldn't. On the occasional Sunday morning when I found it hard to get out of bed, I roused myself anyway. When I did miss a Sunday, I sensed her disappointment; she made me a more faithful attendee than I might have been. It was difficult during Covid, because the church building closed and the congregation gathered by Zoom. The remote services, full of tech glitches, weren't the same. Now we're back to services at ten o'clock in the church, and last week the minister told me that the eight o'clock service would start up again

soon. The news gave me a pang when I reflected that Janet and I would have discussed this development.

After it became clear that her illness would end her life before much longer, she asked me if I had any advice. The question stopped me. To say anything about heaven—that seemed presumptuous, ridiculous, even if in some way I believed in it myself. She endured horrible physical pain. If I could've taken the pain for two or three hours a day to give her a break, I would have. But I could no more do that than give end-of-life advice. I did say something mealy-mouthed about how the possibility of heaven could not be ruled out. After she died, I had a dream in which heaven was not high up in the sky but only about 250 feet above ground and it encircled the globe, coexisting with skyscrapers and mountains and weather and passing airplanes. In this heaven, eternity was real, and ordinary, like when you wake in the morning and realize it's once again Thursday.

She was an amazing and wonderful writer (she might cringe at this introduction). The sense of delight she found in literature, including in her own work, sharpened to an exquisite point. She never wrote a bogus sentence, and I encourage readers of these pieces to look at the sentences one by one. How they achieve their effect remains a mystery. The entire momentum of her life is behind them. I still don't know what advice I could have given her, but I like to think of Janet as quite nearby, maybe just 250 feet up, dwelling forever in a realm of keen and generous delight.

STILL PICTURES

Roses and Peonies

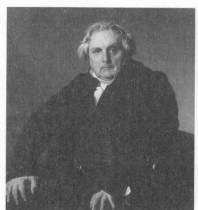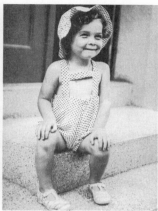

I am looking at two pictures. One is a color reproduction of Ingres's great 1832 portrait of Louis-François Bertin, a powerfully bulky man in his sixties, dressed in black, who sits with both hands assertively planted on his thighs as he engages the viewer with a look of determination touched with irony. The other is a black-and-white snapshot taken sometime in the nineteen-thirties by an anonymous photographer of a two- or three-year-old girl sitting on a stone step, dressed in a polka-dot sunsuit and matching sun hat—the eyes squinting against the sun, the mouth set in a near smile—who has assumed Bertin's pose, as if she had seen the portrait and was mimicking it.

Of course, what she has done, and what Bertin himself

did, was to unconsciously draw on the repertoire of stereotyp-
ical poses with which nature has endowed all creatures, and
which we tend to notice less in our own species than we do
in, say, cats and squirrels and marmosets.

Ingres had a lot of trouble with his portrait of Bertin. He
would start and then discard one version after another. Ac-
cording to a biographer, Walter Pach, Ingres broke down in
tears during a sitting, and Bertin comforted him by saying,
"My dear Ingres, don't bother about me; and above all don't
torment yourself like that. You want to start my portrait over
again? Take your own time for it. You will never tire me, and
just as long as you want me to come, I am at your orders."
Finally, Ingres saw Bertin outside the studio—at a dinner,
in one account, and at an outdoor café, in another—sitting in
The Pose, and knew he had his portrait.

The child in the snapshot is me. I know nothing about
where or when the picture was taken. The sunsuit speaks of
summer vacation, and I am guessing at my age. I say "my" age,
but I don't think of the child as me. No feeling of identifica-
tion stirs as I look at her round face and thin arms and her
incongruously assertive pose.

If I were writing an autobiography, it would have to begin
after the time of that photograph. My first memory dates from
several years later. I am in the country on a fine day in early
summer and there is a village festival. Little girls in white
dresses are walking in a procession, strewing white rose petals
from small baskets they carry. I want to join the procession
but have no basket of petals. A kind aunt comes to my aid.
She hastily plucks white petals from a bush in her garden and
hands me a basket filled with them. I immediately see that

the petals are not rose petals but peony petals. I am unhappy. I feel cheated. I feel that I have not been given the real thing, but something counterfeit.

I have carried this memory around with me all my life, but never looked at it very hard. What gave this disappointment its status over other childhood sorrows? Why did they fade into nothing, while it became a vivid memory? Children are conformists. Was being given petals from the "wrong" flower so afflicting because it set me off from the other children, making me seem different? Or was there something more to the memory than that? Something primitive, symbolic, essential. Are roses better than peonies? When I recoiled from the peony petals, had I stumbled on some knowledge of the natural world otherwise not available to a child of five? Peonies have a brief blooming season. They bloom from late May to early June. It is tempting to buy bunches of them at the florist, with their lovely tight round buds, pink or white or magenta. But when they open, they are blowsy and ugly. You are sorry you bought them. Sometimes they have a delicious fragrance, but often they don't smell at all. In the garden, they are battered by rain and have to be staked after being smashed down. Roses bloom all summer and stand up to rain. As they open in the vase, they grow more beautiful. There is no question of their superiority to peonies. The rose is the queen of flowers.

The idea of absolute aesthetic value is a debatable one, of course. I have inclined toward it, but sometimes I turn from it. I think of the little girl who had somehow wandered into the debate on a beautiful summer day and feel the stirrings of identification.

The Girl in the Train

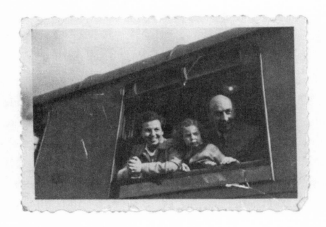

A black-and-white photograph, three and a half by two and three-quarters inches, shows a man and a woman and a little girl looking out of the window of a train. On the back of the photo four handwritten words appear: "Leaving Prague, July 1939." The man and the woman are smiling, and the girl has an expression on her face which the Czech word *mrzutý* conveys more powerfully and succinctly than any of its English definitions: cross, grumpy, surly, sulky, sullen, morose, peevish. *Mrzutý*'s onomatopoetic character expresses the out-of-sorts feeling that the definitions only gesture toward.

The man and woman are my parents, at the ages of thirty-nine and twenty-nine, and the child is me, at the age of almost five. I have no memory of being on the train. As I look

at the picture, I wonder where my two-and-a-half-year-old sister, Marie, was. Perhaps lying on the seat in the compartment, after crying herself to sleep? In the family lore about the leave-taking, there is a nurse whom my sister was inconsolable about parting from.

The train was headed for Hamburg, where the ocean liner on which we had passage to America was docked. It was one of the last civilian ships to leave Europe for America before the outbreak of war. We were among the small number of Jews who escaped the fate of the rest by sheer dumb luck, as a few random insects escape a poison spray. The Nazi bureaucracy that granted us our exit visas in return for bribes (the family story has it that we bought an SS man a racehorse) stipulated—to extract more money from us—that we travel first class on the liner. We were not rich. My father was a doctor and my mother was an attorney in a small law firm. There was no family money. When we arrived in America, we were supported by relatives for the first year. At sea, my parents put on evening dress for dinner; Marie and I were left in our cabin in the care of a ship stewardess. I still remember the gown my mother wore to dinner on the ship; perhaps there were others, but this one hung in her closet throughout my childhood. It was dark blue, some sort of appliqué affair. One day, it wasn't in the closet, and when I asked about it, she said vaguely that she had got rid of it some time ago with other unwanted clothes. It had evidently not been the charged heirloom for her that it was for me.

My memories of the passage were as vague as hers of the expulsion of the dress. There was a boil on my arm that had to be lanced by the ship surgeon, and mid-morning broth

on deck served in tin cups to passengers lying prone under gray, black, and white plaid blankets. I am struck now by how young my parents were when we emigrated. I always saw their Czech past as a huge rock standing before their American present. I read it as a voluminous text that reduced their life in America to a footnote, though in fact they spent the largest part of their lives in this country. Some part of the false idea of my parents as permanent exiles must have come from the fact that we spoke Czech at home. The language fostered the idea of their essential foreignness. My paternal grandmother, who knew almost no English, lived with us, and we spoke Czech on her behalf. She had joined us in 1941, when the Nazis allowed certain older Jews to leave Czechoslovakia. Probably money was again the Nazis' motive. She traveled to Cuba and then came to us in New York.

The first year in America, spent in my maternal aunt and uncle's house in Brooklyn, is largely a blank. I have retained no image of the house, inside or outside. I don't know where we slept or what we ate or did together. My cousins Eva and Helen, who were older and probably resented the intrusion, do not appear to me. The image of a Beatrix Potter book, about which there was a fight, remains as a single unclarifying memento of the house in Brooklyn. But I have distinct memories of the kindergarten in which I was enrolled in September.

These memories are pathetic. They tell of a child not yet familiar with the language of her new country who had been deposited, apparently without explanation, in a class of twenty children and a teacher who believed her to be somehow impaired, what today we would call a "special needs" child. What I needed, of course, was a translator. Probably my

mother's own limited knowledge of English had prevented her from explaining my silent incomprehension to the teacher.

I sat and drew—I have an image of children sitting in low chairs at desks arranged in a circle—I could do that. But I never quite knew what was going on, and there was one memorable sad consequence of that. I had watched my classmates bring money, pennies or nickels, to the class at regular intervals and give them to the teacher. Then, one day, it became clear what the collecting of money was for: an excursion, from which I was excluded because I hadn't known to ask my parents for the contribution. This may have been my first taste of the complicated, self-punishing experience of regret.

Perhaps the most pathetic example of my hit-and-miss, mostly miss, attempts to grasp English was this: At the end of each day, the pretty kindergarten teacher would say, "Good-bye, children." I had formed the idea that Children was the name of one of the girls in the class, and I harbored the fantasy that one day I would become the favorite to whom the teacher addressed the parting words—she would say, "Good-bye, Janet."

In the summer of 1940, we moved to the Yorkville neighborhood of Manhattan in time for me to be enrolled in the first grade at P.S. 82, on East Seventieth Street. During our stay in Brooklyn, my father had studied for, and passed, the medical-board examinations that qualified him as a doctor, and Yorkville in the East Seventies, with its large working-class Czech population, was a plausible place for a Czech-speaking physician to set up a practice. (The Hungarian and German neighborhoods were in the East Eighties.) In Prague my father had been a psychiatrist and neurologist, and

he intended to resume these specialties eventually. But for the present, his only way of supporting a family was to be a village doctor to the Yorkville Czechs. At P.S. 82, I did not have the problems I had had in the Brooklyn kindergarten. Somehow, as if by magic, I had acquired my second language. Like my father, though without conscious intent, I had spent that first year studying.

My memories of the early years at this school are as hazy as my memories of the passage to America. The first vivid memory is from fourth grade. A classmate named Jean Rogers slid into a seat next to me and asked if I would be her best friend. Until this time, I had had no friends. What Jean Rogers said made me happier than perhaps I had ever been. That her overture had been completely unexpected and unsolicited only heightened its powerful effect on me. The Christian concept of grace comes to mind, and as it does so, I am transported from the moment of gratuitous bliss—the word "Christian" is the fulcrum—to a painful and shameful reality of my inner life as a child.

When we arrived in America, and were taken under the wing of my aunt and uncle, who had left Prague six months earlier, we changed our name from Wiener to Winn, as they had changed theirs from Eisner to Edwards, out of fear of an anti-Semitism that was not limited to Nazi Germany. As an extra precaution, my aunt and uncle had joined the Episcopal Church. My parents balked at taking such a step. But they sent Marie and me to a Lutheran Sunday school in our neighborhood and never did anything or said anything to acquaint us with our Jewishness. Finally, one day, after one of us proudly brought home an anti-Semitic slur learned from a

classmate, they decided it was time to tell us we were Jewish. It was a bit late. We had internalized the anti-Semitism in the culture and were shocked and mortified to learn that we were not on the "good" side of the equation. Many years later I came to acknowledge and treasure my Jewishness. But during childhood and adolescence I hated and resented and hid it.

The recoil from Jewish identity was not unique to me, of course, as the term "self-hating Jew" attests. But each case of this anxiety disorder is different. Some of the severity of mine could be attributed to my parents' own confusion about how to represent themselves in their adopted country. In Prague, they knew who they were; they belonged to a community of secular, nationalistic, Czech-speaking Jews who lived confidently among the Czech goyim and were thoroughly identified with Czech culture—as opposed to the German-speaking Jews whose most famous member was Franz Kafka. That is, they thought they knew who they were. After the Nazis marched into Prague in March 1939, it no longer mattered what kind of Jew you were, whether you spoke German or Czech, lit Hanukkah candles, or (as we did) ate carp soup on Christmas Eve. All Jews were vermin to be exterminated. Some of the Czech Gentiles proved to be less philo-Semitic than they had appeared. Anti-Semitism was a fixture of the Czech state, as it was of every other European state. For example, my father could not study literature at Charles University, because the faculty of literature did not welcome Jews. He studied medicine instead. The fearfulness that fueled the change of name from Wiener to Winn was not entirely unwarranted: there was anti-Semitism in 1939 America too, and my parents could not know for sure that they had

found a refuge here. By the time they understood that they had, their children's imaginative life had been deeply affected by their dread.

Who took the picture of my parents and me in the window of the train? I happen to know that it was a distant cousin of my mother's, a man named Jiří Kašpárek, who had accompanied us to the station. He stayed behind in Czechoslovakia and survived capture and imprisonment for his anti-Nazi activities. He was not Jewish, or not Jewish enough to be on the list of the doomed. After the Communist putsch of 1948, he emigrated to America and lived in Pennsylvania, where he worked as a city planner. I had a romantic feeling about him, romantic in relation to my mother: I felt that there had been something between them, and some of the excitement of their (real or imagined) love affair had been transmitted to me. Jiří and his wife, Zdeňka, would visit us in New York, and my parents visited them in Pennsylvania a few times. It took me many years to realize that he was a rather sober man and had certainly never been my mother's lover.

Klara

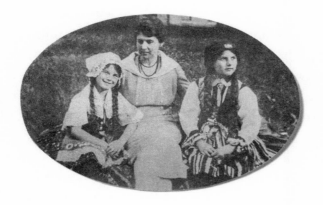

I never knew my maternal grandmother, Klara Munk Taussig, who died, of a pulmonary embolism after a gallbladder operation, when my mother was pregnant with me. I have tried and failed to imagine what it was like to be simultaneously expecting a firstborn and mourning a mother.

The photographs of Klara in the family archive—some of her alone, a few with her husband, Oskar, and most with her daughters, Hanna (my mother) and Jiřina, three years older—are consistently uninformative and flat. In a picture of her and the two girls that must have been taken around 1920, her characteristic rebuff of the camera's overtures is underscored by the girls' openness to them. Hanna, who would have been ten or eleven, is looking directly at the camera and positively flirting with it. Her mouth is a wide upturned

crescent, her eyes merry slits; she is the picture of childhood ease and satisfaction. Jiřina responds differently to the camera's attentions, but is no less complicit with its agenda. She is looking to the side, but in a way that reflects her awareness that she is being scrutinized. She is a beauty. She knows it and likes it but not all that much; there is a sadness in her that trumps her vanity and would remain her signature. When I knew her as an aunt, I felt her kindness, graciousness, reserve, and melancholy. Klara, who sits between the girls with her arms around them, simply ignores the camera. She looks down at Hanna in a straightforward, unselfconscious way. She wears a discreet, well-made dress of the time. She looks like a generic mother figure in a child-rearing manual.

In one respect, however, Klara was not generic at all. Evidently, she had a streak of avant-gardism in her. She had radical notions about how to furnish her bourgeois Prague home. Probably today's eye would be struck more by the nineteenth-century character of the rooms than by their deviations from the Victorian norm. But Klara had picked up the idea of the "modern" and run with it. My mother would talk proudly of how "ahead" Klara was of her women friends (with whom she met weekly in a fashionable café to drink coffee with whipped cream and eat Sacher torte), of her advanced taste, and of the interesting artifacts she was always introducing into the household that it was beyond her friends to "see" until Klara taught them to. Unfortunately, there are no photographs of the apartment my mother remembered with such fond vividness. The only relics from it are the white linen tablecloths and napkins and doilies that were in my mother's trousseau, invoking not the social progress im-

plicit in the new *Sachlichkeit* but, rather, the hideous labors of embroiderers and lace-makers that Adolf Loos condemned in his modernist manifesto "Ornament and Crime." Most of the photographs of Klara and Oskar and their daughters were taken in studios. No glimpse exists of the delicious, remarkable Taussig apartment.

I have inherited, or at any rate share, Klara's interest in interior design. As a child, I played with dollhouses that were orange crates furnished with chairs and tables and beds contrived out of this and that piece of wood or metal or cloth scavenged from around the house. I feel a bond with the grandmother I never met over our shared preoccupation with this most inessential and ephemeral of forms. My handsome apartment will go the way of hers. There are photographs of it, but in their way they are as poker-faced as the photographs of Klara.

The reader will have noticed that in the photograph of the mother and her daughters the girls are wearing what were called "Czech national costumes," made up of white shirt-waists and dark bodices and lavishly decorated full skirts. Hanna also wears a white embroidered mobcap over her long braids, and Jiřina has on a sort of dark turban that enhances her classical beauty. Marie and I wore such costumes in New York during the Second World War, when there were gatherings of Yorkville Czechs for some celebration of the Czechoslovak government-in-exile. Czechoslovakia had come into being after the First World War, carved out of the Austro-Hungarian Empire; the secular Jewish Taussigs were part of the Czech nationalist movement, identifying as Czechs rather than as Jews and taking huge pride in what was spoken of as the "model" Masaryk democracy.

Do you remember the noble Czech resistance leader played by Paul Henreid in *Casablanca*? That this paragon was Czech rather than Polish or Hungarian or from any other Nazi-occupied country is a reflection of the high regard in which Czechoslovakia was held in the Allied world of 1942. Today, no one in their right mind can stand this self-satisfied sap or understand why Ingrid Bergman chooses him over Humphrey Bogart. It is to my credit and to my sister's that we couldn't stand most of the Czechs in our parents' circle of émigrés.

Only some of them were Jewish; most of them, especially the men, possessed the qualities we found typically and odiously Czech, chief among them their humor. What arguably might have been funny in Prague was an embarrassment in New York. At least to us children. I cannot illustrate this, but I can still feel our icy contempt for the elaborate attempts of those idiots to be amusing. But note this: we did not feel critical of our parents. Their Czechness was okay. Their humor—our family humor—was of the highest quality. All happy families are alike in the illusion of superiority their children touchingly harbor. Later in life, I began to grasp the dangerous playfulness of Czech, the wit and charm it inspires in the light-fingered and the boorishness it draws from the ham-fisted. The boorishness of some of my parents' friends may have been innate; they might have been just the same had they come from Cleveland rather than from Praha. But I associate it with a special Czech atmosphere.

As for the inscrutable Klara, I have the feeling—though I have very little to go on—that she was preternaturally kind and good, and a little deficient in the humor department.

Late in her life, my mother told me something about Klara that was like a turn of the kaleidoscope from an exquisite image to a less pretty one. She said that Klara, who had no means of her own, never received enough money from Oskar for maintaining the household as she wanted to maintain it, and that this was a perpetual struggle between them. I immediately thought of Nora in *A Doll's House*, abjectly cajoling her husband to give her money. I know even less about Oskar than about Klara. He was a lawyer, and my mother adored him and worked in his law firm after she got her law degree. I see some resemblance to myself in pictures of him. That is all I can say about Oskar. If I had known I was going to write about him, I would have asked my mother questions. But now I am like a reporter with an empty notebook. Oskar is out of reach. Klara is slightly less so because of the accident of my mother's nostalgia about her childhood home.

Jiřina and Hanka

This picture of Klara and her daughters would have been taken seven or eight years earlier than the one in which the girls wear national costumes. It is a studio photograph, with the soft lighting and formal poses that are the genre's signature. The three figures wear white dresses. Little Hanka, who couldn't be more than two or three, once again draws the viewer's charmed gaze. She has obeyed the photographer's command to sit still, but she is doing something funny with her left hand. She is digging it into her mother's thigh in a gesture that I immediately recognize and feel I have seen my grown mother perform, some sort of unconscious act of mushing or squishing something. The Czech word *patlat* expresses it. *Upatlaný*, applied to food, refers to dishes that have been

over-meddled with. Someone has done to them what my mother is doing to her mother's thigh. Jiřina already has the remote look of the later picture, though she has not yet grown into her beauty. Klara is the photograph's still center.

My mother idealized her sister. She spoke not only of her beauty but of her brains. She said that Jiřina was the one with real intellectual equipment, while she, Hanka, had none to speak of, didn't know anything thoroughly or do anything properly, was some sort of fake. I'm not sure that I am ready to write about my mother yet, so I will write about the peripheral Eisner/Edwardses instead as a sort of warm-up exercise. Do we ever write about our parents without perpetrating a fraud? Doesn't the lock on the bedroom door permanently protect them from our curiosity, keep us forever in the corridor of doubt?

But wait a minute. This metaphor (which may be wrong in general) is particularly wrong for my parents, who did not share a bedroom. In Prague, like most other upper-class and upper-middle-class couples, my parents had separate bedrooms. In New York, in their reduced living quarters, they had to create separate bedrooms out of parts of the apartment used for other purposes: my mother slept on a large studio couch in the living room, and my father slept on a standard studio couch in his study. When Marie and I learned about sex, we assumed that they did it on the large studio couch.

Jiřina's husband, Paul, was a lawyer and businessman. He had been successful in Prague and was successful here. Soon after we moved to Manhattan, the Edwardses moved from Brooklyn to Forest Hills, to a brick house with a garden. We often drove out to visit them on weekends. It has just occurred

to me, as it never occurred to me as a child, that they never visited us. We were the poor relations. What could we offer them in our small apartment in a building on tenement-filled far-east Seventy-Second Street? I later learned that there had been a struggle between my parents about the visits to Forest Hills. My father didn't like the rich/poor setup. He didn't like Paul. It is not hard to see why. Paul was a vibrant, forceful man who liked to be the center of attention—he was a brilliant storyteller—and hold children up in the air and tickle them. My mother passionately loved her sister and by extension loved her husband. I think my father was jealous of my mother's mildly eroticized affection for Paul. But the visits were not happy for my mother, either. There were always a lot of people at the Edwards house—business associates of my uncle's—and Jiřina, the dutiful hostess, was not available to her sister. I see her carrying trays from the house into the garden, and almost hear her nervous laugh.

During one of the weekend visits to Forest Hills, Uncle Paul taught me how to wash my hands. He had caught me doing what children do, running a bit of water over my hands and then dirtying a towel with them. He instructed me on how to thoroughly soap both hands and rinse them and only then dry them. Another visceral memory of my uncle comes from the dinner table at the house in Forest Hills: I remember the deliberation with which he chewed his food, the assurance and self-confidence the working of his jaws seemed to express. And something else: at one of the meals there was a small bowl on the table, and I saw my uncle take a spoon and help himself to its entire contents. All of it! Was it a dish

made expressly for him? Or was he brazenly flouting the rule that you should never take the last of anything?

We considered our family vastly superior to the Edwardses. They were in the world of money and business, and we fancied ourselves in the world of literature and art. In fact, we were an ordinary middle-class, middlebrow family. My parents belonged to the Book-of-the-Month Club. My father wrote letters to the *Times*, and one of them may have made it into print. After he died, we found in his papers dozens of copies of this letter, correcting an error in the column of the nature writer Hal Borland, and a letter from Borland, amiably acknowledging his error. In Prague, the claim to artiness had more substance. My parents were part of a circle of artists and intellectuals to which Karel Čapek belonged. My father published witty pieces in advanced periodicals. His wit was excellent—but it was Czech wit. He wrote perfectly well in English, but he could never be a real writer in that language. He had preposterous ambitions for his daughters. We would cringe when he talked about the "bestsellers" he expected us to write.

I am writing this in a house in the country with its obligatory box of family letters in the attic that go unread year after year. Yesterday, I brushed the dust and dead flies off the box and began to read. Autobiography is a misnamed genre; memory speaks only some of its lines. Like biography, it enlists letters and the testimony of contemporaries in its novelistic enterprise. Combing through the box, it was not long before I struck the gold of a letter that confirmed and amplified the portrait of Uncle Paul that I am now drawing

seventy years on. The letter, dated June 26, 1949, was written by my fifteen-year-old self to my parents, about a car trip I took with my uncle and aunt and cousin Eva to a village in Maine called Vassalboro where they had rented a house for the summer. "We set out early with Eva driving. . . . For most of the trip I shocked the Edwards' by telling them every dirty joke I knew," I wrote in a mannered girl's hand on light-blue stationery rimmed in dark blue:

> Then Aunt Georgine [Jiřina's American name: Jiři = George] started to tell a joke. Uncle Paul got very excited and said she would have to get out of the car if she told it. After much ado it was told and for ½ an hour we tried to get it. Finally we did and it wasn't even funny.

Paul's threat dovetails with my memory of his willful character. The sense of poor Georgine's humiliation, the way Eva and I join the strong man against the weak woman ("it wasn't even funny"), leaps out of the text. But what does it prove? I don't know if my uncle was a domineering husband. I don't know what the chronic exaggerated joking in the Edwards family meant about their deep relations. The gold is dross. The glitter of memory may be no less deceptive. The past is a country that issues no visas. We can only enter it illegally.

Slečna

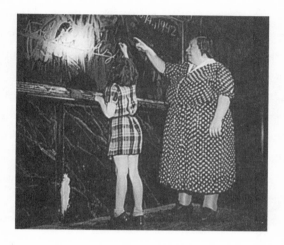

Slečna Vaňková was an obese woman with short, straight hair and coarse, swarthy skin who always seemed to be sweating. She wore long dark-red print dresses, all of which appeared to be the same dress, and heavy black shoes. She was the teacher at the after-school Czech school in Yorkville that Marie and I attended. Slečna was not her first name. It is the Czech word for "Miss." I don't know, and never knew, her first name. She was simply Slečna to the class, which met two afternoons a week in a building on East Seventy-Third Street called Národní Budova, or National Hall. The second-generation working-class Czechs in Yorkville sent their children to the school to learn to read and write their native language.

We did sort of learn to read and write Czech, but mostly we fooled around. The boys in the class plagued Slečna with their boys' wild disruptiveness. She was constantly yelling at them, but was unable to control them. The girls disrupted the class in other ways. We whispered and passed notes. One day, a pair of twins called Janice and Rose Hastava brought in a pomegranate split in half and dispensed seeds to a favored few. I was not among them.

Slečna was not disliked. It was understood that she was kindhearted. But we were too young to be kind in return to someone so weak and (clinching our hard-heartedness) so unattractive. Today, I wonder about where and how she lived, what she did when she wasn't teaching the class, how old she was. Back then she was just Slečna.

Teaching reading and writing was not her main task. To raise money for the school (it was free), she was required to write and produce a semiannual play or musical with a part in it for every child in a class of around twenty-five, staged on the top floor of the building, where there was a proscenium stage and old-fashioned flats depicting forests and gardens and rustic interiors. One of Slečna's most memorable productions was a Czech version of *Oklahoma!* that has permanently left Czech lyrics to the music of Richard Rodgers in my ear. So instead of learning to read and write, for a large part of each term we endlessly, cluelessly rehearsed, first in the classroom and then upstairs on the stage. A thin, affrighted woman named Slečna Kopřivová played the piano for the musical numbers. Opposite the stage, at the far end of the room, there was a bar where there were always some men drinking. The

place smelled of beer and of a kind of evocative staleness perhaps inherent to nineteenth-century New York buildings.

Sites of idleness and wasted time like the Czech school are fertile breeding grounds for the habit many of us form in childhood of always being in love with somebody. Eros was in the air of Slečna's unruly classroom. I had a crush on a boy named Zdeněk Mateyka, and experienced my first taste of sexual jealousy. The object of that lowering emotion was a girl named Anna Popelarova. The boys were always showing off for her. She had all the mythic attributes of desirability: she was beautiful, vivid, self-contained. I envied everything about her, not least her blue jeans, which were faded and soft, unlike my own immutably dark, stiff ones—in those days, you couldn't buy prefaded jeans; you had to earn the light-blue color and softness. Anči, as she was called, probably inherited her jeans from a brother or sister, but at the time their desirable fadedness seemed like another of her magical attributes. I was part of the background of ordinary girls, who secretly loved and, unbeknownst to ourselves, were grateful for the safety of not being loved in return. The pleasure and terror of that would come later.

About twenty years ago, I unexpectedly received a package in the mail containing ten or twelve black-and-white photographs. The return address was the Library of Congress, and the sender was a library employee who had somehow connected me to the family that appeared in the photographs and thought I might like to have them. I certainly did. The family was my family. The pictures were not snapshots; they were glossy eight-by-ten prints that had a professional, you could

even say slick, character: the sort of photographs that appeared in *Life* and constituted a kind of picture story of harmless everyday life. They showed us at home around the dinner table, in Central Park—Marie and me roller-skating around the lake and eating Popsicles at Bethesda Fountain—in class at public school, and at Czech school (thus the picture of Slečna and me at the blackboard). They were taken in 1942, by a photographer named Marjory Collins who worked for the Office of War Information in Washington. Her boss was Roy Stryker, who as the head of the photography unit of the Farm Security Administration had famously elicited—from Dorothea Lange, Walker Evans, Russell Lee, and Carl Mydans, among others—the images of rural poverty that gave the Depression its unmistakable face. After we entered the Second World War, Stryker's unit was moved out of the FSA into the OWI and given a new mandate. Now America was to be represented as the locus of the struggle of ordinary, decent people against the German and Japanese threat. Pictures of young women on assembly lines making airplane parts and of Roz Chast–like retired couples tending victory gardens were among the new indelible images. Marjory Collins's photographs of our family belonged to a special subsection of the general propagandistic project. According to a short biography of Collins written by Beverly W. Brannan, a curator of photography at the Library of Congress, the photographs of "'hyphenated Americans,' including Chinese-, Czech-, German-, Irish-, Italian-, Jewish-, and Turkish-Americans . . . were used to illustrate publications dropped behind enemy lines to reassure people in Axis-power countries that the United States was sympathetic to their needs." I love the

thought that pictures of Marie and me eating Popsicles at Bethesda Fountain were dropped behind enemy lines. I love the phrase "behind enemy lines." I have no memory of the sessions with Marjory Collins. She must have spent several days with us. The photograph of us at dinner shows an empty place at the table where she must have sat after taking her pictures. The images reflect a charming and likable person who made us all seem charming and likable, if a little boring. I suspect that the exciting, Arbus-like picture of the grotesque Slečna was one she would have preferred not to have taken.

Daddy

Sometimes, when something displeased him, an ugly expression would appear on my father's face. It disappeared in a moment and was related to nothing about him. He was the gentlest of men. He never punished us (it was my mother who occasionally spanked us), and we never knew him to be unkind to anyone. But the ugly expression—as though he were flinching from a horror—did appear and was all the more striking because of its incongruity with his usual mild demeanor.

Parents have their mythologies. The myth of my father

was that at the age of ten he had left his home in a small Czech village called Poděbrady* and gone to Prague to study at the *gymnasium*, supporting himself by tutoring less clever students. It wasn't until after his death and late in my mother's life that it occurred to me to question her about this remark- able story. How was a ten-year-old boy able to live alone in a big city? Where had he lived? Was he really completely on his own? Well, no, it turned out. He had lived with relatives. The tutoring contributed to, but did not constitute, his up- keep. The story remained obscure—I never learned who the relatives were—but was no longer improbable.

Another part of my father's mythology was his charac- ter as a man-about-town in the years before his marriage to my mother. He married late—at thirty-two—as men did in those days, as, for example, Freud did after a long engage- ment to Martha when he could finally afford the furniture, silver, and porcelain for their apartment in Vienna. By the time I knew him, my father was a bald, slightly flabby, middle- aged doctor on whom a history of girl chasing had left no visible trace. But the legend of his rakishness persisted, so that Marie and I could (not altogether seriously) speculate about romantic liaisons between him and women friends of the family. He sometimes said of himself that he had better relations with women than with men—but this was not to boast about his relations with women so much as to express regret about his relations with men. He had grown up with-

* It turns out that this picture of Poděbrady was part of the mythmaking; it seems in fact to have been less the peasant village of my imagining than a tiny provincial town.

out a father and believed this was at the root of his inability to form strong friendships with men. His mother and father had divorced soon after he was born. Details about his father, Moritz Wiener, are elusive, almost nonexistent. My father and his older sister, Maria, grew up in the household of their maternal grandmother, Jennie Růžičková, who had had thirteen children and ran a sewing business in Poděbrady.

The Růžičkas were practicing Jews, but Růžička is not a Jewish name. My father told us that an ancestor bought it from a state official. Jews had been compelled to buy non-Jewish names; there was a stock of them to choose from and prices varied according to their pleasingness. Or so the story went. This may be another myth. We do know that laws were passed in the eighteenth century requiring eastern European Jews to adopt non-Jewish names, but no record exists of the sale of these names or of graduated price lists. Still, the legend of the store-bought name persists and retains for me its innocent allure. I find it nice to think that the ancestor who supposedly bought Růžička—which means "little rose" in Czech—was not cheap about his momentous purchase.

I imagined my father's life in the village as something out of late Tolstoy: a peasant culture of want, harshness, and discomfort; sledges chased by wolves through the snow, not enough to eat, everything scratchy and uncouth, nothing easy, nothing pretty. Some of this idea of my father as a sort of liberated serf must have come from my mother. She didn't exactly put on airs, but we picked up on her feeling of superiority, not to my father himself—whose virtues of mind and character were not lost on her—but to his unfortunate roots, his too-late exposure to Taussig ease and elegance.

Sometimes I noticed a special pleasure, almost a rapture, in him when he came out of the cold into a warm house or when he ate something that he liked, and I linked this to the days of deprivation. I felt it to be some sort of reflexive memory of relief from discomfort and want. I'm inclined to think that this is an example of my sensing something real rather than imagining things.

Another of my father's mythic qualities was his skill as a diagnostician. Although he was both a psychiatrist and a neurologist, his feats of almost uncannily correct diagnosis were in the latter field. I own a huge, magnificent pen-and-ink drawing by the modernist sculptor Bernard Reder depicting the stations of the cross, which he gave to my father in gratitude for ridding him of an affliction of the right hand that prevented him from working. He had gone from doctor to doctor to doctor. My father swiftly diagnosed the condition and cured it with a simple home remedy. When a medical journal published his article "Chronic Progressive Chorea Masquerading as Functional Disorder," we were confirmed in our sense of his exalted standing in a rarefied field. We were less awed by his work as a psychiatrist. This was the so-called heyday of Freudian theory in America. Psychiatrists were psychoanalysts manqué; they talked the same fancy language. They treated sicker patients, depressives and psychotics, but believed that the talking cure, designed for neurotics, could help them. The mystery of madness hangs over the world like a cry at night. The children of psychiatrists are no less crassly derisive about crazy people than the rest of the sane world. We would make dumb jokes about the nuts Daddy treated and about loony bins and laughing academies. My father

good-naturedly accepted our cruel, stupid talk. He was always sympathetic to fun. There is a particularly wonderful expression in the invented émigré genre of mixed-up Czech and English: *lotofánek*, that is, a lot of fun, set in the diminutive form that Czech nouns helplessly gravitate toward. Daddy had no side. He may be the least pretentious person I have ever known, he never pulled rank on anyone, he had no fear of losing face.

He loved opera, birds, mushrooms, wildflowers, poetry, baseball. I am flooded with things I want to say about him. He left more traces of his existence than most people do, because he was always writing things down, on little cards, on onionskin paper (his poems), in diaries, even on the walls of the cabin on a lake where he and my mother spent weekends and summer holidays. My mind is filled with lovely plotless memories of him. The memories with a plot are, of course, the ones that commit the original sin of autobiography, which gives it its vitality if not its raison d'être. They are the memories of conflict, resentment, blame, self-justification—and it is wrong, unfair, inexcusable to publish them. "Who asked you to tarnish my image with your miserable little hurts?" the dead person might reasonably ask. Since my father was not concerned with his image, he would probably not object to the recitation of my wounded-child's grievances. But I do not wish to make it. He was a wonderful father. I know he dearly loved my sister and me. But he loved his own life more and seemed to have hated leaving it more than most men and women do.

We are each of us an endangered species. When we die, our species disappears with us. Nobody like us will ever exist

again. The lives of great artists and thinkers and statesmen are like the lives of the great extinct species, the tyrannosaurs and stegosaurs, while the lives of the obscure can be likened to extinct species of beetles. Daddy would probably not find this conceit of great interest. He moved along his own trail. He liked to pick and identify certain small, frail, white wildflowers that it never occurred to me to notice, and that he never forced on my attention.

School Days

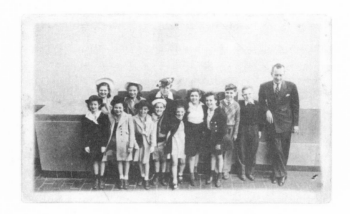

The room where typing was taught at P.S. 96, the junior high school for girls I attended on Eighty-Second Street and York Avenue, was like a nineteenth-century factory floor. Identical Underwood office typewriters sat in rows on tables with stools in front of them. An intoxicating smell of ink filled the room. We sat at these machines as a large, dark woman named Mrs. Schroeder—our foreman, so to speak—moved among us and unhurriedly (the course went on for two years) turned us into expert, fast-as-hell touch typists. I also learned to cook and sew at P.S. 96. The original idea of the school in what was then a working-class neighborhood was to pre-

pare its girl students for the real life they would enter when they graduated from ninth grade. They would get secretarial jobs or marry. By the time I attended, most of the students were going on to high school, but the curriculum remained largely unchanged. The cooking course was preceded by the sewing course: we made aprons and hats out of white cotton fabric trimmed with red binding to wear while we prepared parsleyed potatoes.

Joseph Mitchell once asked me if I thought of myself as lucky. I unhesitatingly said yes. I thought of having escaped the Holocaust and of being among the small number of people in the world who don't live in abject poverty. But in regard to certain particulars of my life I might have answered differently. I was not lucky in my education. At P.S. 82, my grade school, teaching was done by rote, by well-meaning, uninspiring women teachers. Our time was spent making colored maps of the world showing, for example, that tin was the chief export of Bolivia. I evidently did the coloring so nicely that I was "skipped" half a grade. As a result I missed the crucial moment when the dopey rote learning of arithmetic ends and the (exhilarating, I'm told) study of mathematics begins. Thereafter I never understood anything in the subject. I never made the leap. I could never rid myself of the old counting-on-your-fingers habit of mind. I never learned Latin or Greek; I didn't read Shakespeare until college. At the High School of Music and Art, the "special" public school I "got into" for art, I learned almost as little as I did in grade school and junior high school. Going from P.S. 96 to Music and Art was a heady experience. I went from drabness and dullness to

excitement and delight. We had been admitted into a land of treats like the one in *The Nutcracker*. The idea was to nurture the students in their respective fields of special promise while providing a regular academic education. But the main thing seemed to be to make us happy. The idea that we ourselves were special was transmitted to us without difficulty. The music department must have been more rigorous, but the art classes were perfunctory (there was no drawing course); this was the time of Abstract Expressionism, and we made lame Abstract Expressionist paintings in the studio classes. The academic teaching was equally lite. I remember learning about the Taft-Hartley law in a class taught by an excited lefty, though we didn't think of him as a lefty; he was what everyone was, the way tap water was what water was. There were still actual Communists running around the country in the late forties, and there was a girl in my class who called herself a Communist. I remember talking with her in the bathroom; I asked what it meant to be a Communist, what was it about? And she said it was about dialectical materialism. I said, "Oh," pretending to know what that was. The young know better than to admit their ignorance. Their pretended certainty is their armor against the depressing know-almost-nothingness of the adult world. In college (the University of Michigan) I was exposed almost for the first time to excellent, occasionally even brilliant, teaching.

The photograph at the head of this section was taken high up on the Empire State Building. The group is one of my classes at P.S. 82. I am in the front row, third from the left. The old lady with the hat in the back row is our teacher, Miss

Smith. The man may or may not be the school principal. The picture brings back no memory of the excursion. I am struck by how different some of the girls look from girls of today, as if they were living in the nineteenth century and being photographed by Mrs. Cameron.

Camp Happyacres

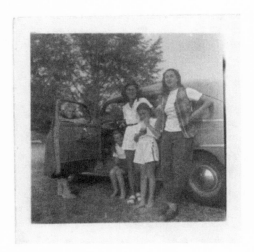

This barely readable, two-by-three-inch black-and-white photograph of my sister and me along with three people I don't recognize posed in front of an automobile is typical of the photographs we find in boxes of old papers. It has no artistic merit and summons no memories. Occasionally, however, like memory itself, one of these inert pictures will suddenly stir and come to life. As I peer more closely at the snapshot, I recognize someone in it—the woman who is leaning against the open car door and looking through the window—and am taken back to Happyacres, a girls' camp in New Hampshire where our parents sent us during the nineteen-forties,

and to the lake with the Nabokovian name of Pleasant Lake in which we swam every day. The lake was three and a half miles distant from the camp, and we almost always walked there and back because it was wartime and there was no gas. On exceptional days—and here is where the woman in the car window comes in—she drove a few of us to the lake and back in her gray car. She was the mother of a fellow camper named Marty. I no longer remember—if I ever knew—why Marty's mother was able to get gas, and what she was doing at Happyacres. There may have been some tragic story, or there may not. There are not a lot of things I remember about these summers. Most of what happens to us goes unremembered. The events of our lives are like photographic negatives. The few that make it into the developing solution and become photographs are what we call our memories.

Happyacres was run by a Congregationalist minister named Stewart Campbell and his wife, Marion. These good-hearted people had registered with some Christian agency that was sponsoring camp scholarships for the children of war refugees. The Christianized Edwardses had found the camp for their daughters and then steered my parents to it. It was situated in the small village of Wilmot, and consisted of a nineteenth-century white clapboard house, a tall, stained-wood one-room building called the Lodge, a lawn and flower garden, and various tents and cabins at the edge of a small woodland.

We called the Campbells Uncle Stewart and Aunt Marion. He was a tall, thin old man, remote, with a strict and cold certitude; she was a short, fat old woman with a warm manner that didn't go over. I remember her smell when she hugged

me. She was given to hugging and saying, "Bless your heart." Her smell was of the body and the cooking she did for the camp. There are old people who endear themselves to children, but they are exceptional. As a rule children like grownups who are young, and the rule held at Happyacres. We were only interested in and excited by the pretty young women who were our counselors. The Campbells were just part of the neutral background against which the candy-colored slides of childhood are projected. The most popular and possibly the youngest of the counselors was Sunny, who was beautiful and blond and deliciously indiscreet. She would tell us about her boyfriends. She was easy and friendly. I have a memory of her on the deck of a boat on Lake Winnipesaukee dancing with a man. It's not a visual memory; I don't see her and the man. Rather, I hear a sentence—"Sunny is dancing with a man to 'Stardust'!"—excitedly whispered among the campers who were on board the boat that was taking us around the lake. I faintly recall that someone—probably the Campbells—put a stop to Sunny's dancing. I had no idea then what "Stardust" was. When I heard the song later in life, I was disappointed. It had none of the mystery of the name that shimmered on the boat deck.

The camp was tame. By the time Marie and I became campers, its glory days were over. Glimpses of those days were given to us in the Lodge, in framed black-and-white photographs of girls engaged in sports and activities no longer offered at the camp. The activity I most regretted was eurythmics. The pictures of girls in Grecian tunics with arms raised in absurd stylized poses looked thrilling and wonderful to me.

Now we just made lanyards and balsam pillows and walked to the lake and back. But there was also Sanctuary.

Every day, in the mid-morning, Uncle Stewart would lead us along one of the trails in the woods to a clearing where there was a sort of shrine. There we participated in a service that was largely Christian but also partly American Indian. The appropriation by American camps of Indian traditions, true and invented, is a subject that would reward study. When the indigenes roasted marshmallows around their fires five hundred years ago, they could hardly have foreseen their contribution to the semiotics of the twentieth-century American camp. I remember liking the biblical psalms Uncle Stewart read aloud in the clearing and liking Sanctuary itself. Children are mystical-minded creatures; they sense the strangeness of it all. As we settle into earthly life, this sense fades. I remember some sort of otherworldly vision that came to me on a hillside in the Catskills when I was six; and I sometimes had powerfully terrifying dreams (they usually came when I was ill) about round forms slowly, harrowingly destroying each other. I told no one about the vision or about the dreams. Children are always feeling secretly ashamed or anxious. At Happyacres we said grace at every meal: "We thank Thee, Lord, for all things beautiful and good and true; for things that seem not good but turn to good; for all the sweet compulsion of Thy will. Amen." We stumbled over "compulsion." Having no idea what it meant, we substituted "complexion," as if that made better sense. The American Indian idea shaped the camp motto: "To seek beauty everywhere, and to leave the trail more beautiful because we have passed by." I have had some interesting things

happen to me in my life, but I remember nothing about them as precisely as I remember the grace and the motto. Yes, the strangeness of it all.

I remember the smell of phlox in Aunt Marion's garden. Years later when I had a garden of my own, I grew phlox for a while, for its evocative smell, but the plant was susceptible to mold and wasn't pretty, and I phased it out. It was a madeleine that didn't earn its keep.

Francine and Jarmila

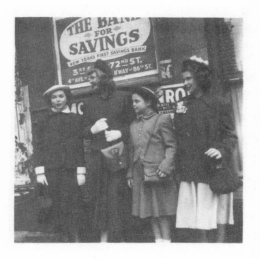

Although this is a black-and-white photograph, I know the colors of the clothes Marie and I are wearing. It's Easter Sunday. We are in our new spring outfits—for which we were taken shopping every year—to wear in the Easter Parade on Fifth Avenue. I had chosen a navy-blue suit and a green suede handbag and green hat; I remember feeling proud of what I thought of as my startlingly original choice of green with dark blue. Marie is wearing a pink suit. I don't remember the color of her hat and handbag. I do remember my mother's disapproval of her choice of pink. Marie was slightly plump, and my mother thought that pink was not a flattering color for

her. But Marie wanted the pink suit and would not be talked out of it. As I look at the picture, it seems to me that she made the right choice. She looks like a beautiful child, the most beautiful and beautifully dressed of the four girls. The other two girls are Francine Reese and Jarmila Neuman, also known as Jerry Neuman. Marie looks to be about ten and the other girls are two or three years older.

Francine lived across the street from our building on East Seventy-Second Street, in a tenement, and was my best friend. She was a tall girl with attitude. She was bold and fresh. My mother didn't like her. She didn't think she was a proper friend for me. Of course, this was what I liked about her: she was the bad girl I was not allowed to be. Jerry lived in Schenectady. She was probably visiting with us during the Easter holidays. At other Easters, Marie and I would be sent to Schenectady to stay with the Neumans. I am hazy about the reason for these exchange visits and about our family's connection to the Neumans. They were fellow Czech refugees; my parents had known them in Prague. I remember almost nothing about the visits to Schenectady except that they were neither wonderful nor terrible. It was just something we did among all the other things children do for no reason they feel the need to inquire into. There was an older Neuman daughter, Vera, who was already living on her own and writing for a newspaper. I remember a story about the father, Kamil, who had been a physician in Prague and, like my father, had to take the state medical boards before being allowed to practice here. Except, unlike my father, he could never pass the exams. He failed them time after time. The story was that he became so desperate, he took to begging in

the subway. I don't know if this story is true. But it was bizarre enough to have stayed in my memory. Kamil must eventually have passed the exams, because he was a practicing doctor when we visited in Schenectady. I remember him as a small round man and his wife, Anka, as an easy, hearty woman. They are like minor characters in an early draft of a novel who have not made it into the final version. Easter meant nothing to us as Easter. It was just the occasion for the new clothes. It was only many years later that I attended an Easter service in a Catholic church, and understood the momentousness of the holiday.

Four Old Women

VILMA LÖWENBACH

She and her husband, Jan, were fellow refugees from Prague. He was a distinguished scholar of I don't know what; older than Vilma, white-haired, stooped, recessive. She was a vigorous woman of extraordinarily large sympathies with a kindly, eager face. In their early years in New York, the Löwenbachs lived in a shabby walk-up in the West Forties. I was taken to see them there once, and the flat—with its Biedermeier furniture, walls of books, old paintings in gold frames, and faded Persian carpets—made an indelible impression as a kind of mirage of Old World belletristic culture. Years later, after Vilma inherited a fortune from a relative, I visited the Löwenbachs in the co-op apartment they had moved to in a handsome new building on Fifty-Fourth Street, across the street from the Museum of Modern Art, and I was disappointed. The place was no longer a mirage. It was just a perfectly well-appointed apartment with some good old things in it.

I think of Vilma dressed in longish wool skirts and silk crepe blouses with plain round necks. The colors were subdued: beige, gray, brown. Women then dressed differently than they do today. Back then, not only old women but women no longer in their first youth dressed differently from

the young. In the nineteen-fifties and sixties, I used to look at the beautiful oversize *Vogue* and *Harper's Bazaar*, with photographs in them by Richard Avedon and Irving Penn, and I admired but never coveted the clothes the models wore. I wasn't old enough to wear clothes like that. They were for the Madame Merles and Mrs. Paleys of later life, beautiful, rich, even immoral if necessary. Then, in the nineteen-seventies, *Vogue* and *Harper's Bazaar* shrank in size, and the clothes in their pages were no longer designed for the mysterious older woman; they were for the barefaced young and have been ever since. The old-lady clothes of my youth have similarly disappeared. Today, women of my generation—old ladies— try to find things in the shops and catalogs that don't look ridiculous on us. It's the best we can do.

Vilma had two daughters, Eva and Mima. Eva and her husband had escaped Hitler and gone to Argentina; Mima and her husband had gone to Canada. Eva and my mother had been friends in Prague, and corresponded during the war, comparing notes on domestic life in their respective countries of exile; their letters somehow reached their destinations. Eva died tragically, of melanoma, in the late nineteen-fifties. I remember pictures of Mima, who was a nurse, squinting behind round eyeglasses. There were no pictures of Eva, who was said to have been good-looking.

I remember my mother telling me of remonstrating with Vilma to take taxis instead of buses after she inherited her fortune. I would later do the same with my mother's own frugality. No fortune had come to her, but she, too, could afford to live more comfortably than she did on the savings my father

left her. The habit of frugality is hard to shake. It isn't that my mother was anxious about money. I'm grateful to her for her example throughout my childhood of never seeming to worry about money. Both my parents worked, and there wasn't ever a lot of money, but there was enough. And money wasn't important, my mother liked to say. There were the higher things. Some of this was a pose, of course. But as poses go, it wasn't a bad one for a child to accept as evidence of a parent's superiority.

Vilma was known for her public benevolence, but I don't know what she actually "did." I only know that a few years before her death she gave my mother a charming nineteenth-century painting of a young girl and a small, elegant Biedermeier cabinet, which, in turn, my mother gave to Marie and me, the painting to Marie and the Biedermeier to me. The cabinet sits near a radiator, and in the winter I put a bowl of water on it to try to temper the heat that is dulling its two-hundred-year-old gloss.

JULIA BACKER

She was another refugee from Prague, a widow with grown children. I knew her as Julinka. She lived in one of the great old apartment buildings at the end of West Seventy-Second Street, where it curves and opens onto Riverside Drive. I recall a room that was like a room in a palace. Two harps nodded to each other across vast spaces, and huge windows looked out on the Hudson. Julinka played the harps; she had

been a professional musician. She was small and birdlike in her movements and one of the people who seem to like everything. She invited me once to hear Birgit Nilsson sing in *Tristan and Isolde* at the Metropolitan Opera. She was ecstatic, speaking of the silver in Nilsson's voice, then no longer a young one. The beauty of Nilsson's singing and the greatness of the opera were lost on me. I was not schooled in Wagner. Julinka didn't seem to care about my response, though I tried to be politely grateful. My mother loved her, and I believed I loved her, too, though there was never any reason to—as if a reason were needed to love songbirds.

GRETA HONIG

She was a tall, angular woman who always seemed to be out of breath. She rushed around the city on philanthropic errands. Her panting do-goodism was an object of my father's mockery. He may have detected some falseness in it; he was generally not unkind about people. But I had a sneaking liking for her because of her elegance. She stood out for me from the other women who were my mother's friends in the geometric modernism of her clothes and the arty spareness of her apartment, in a small building on Lexington Avenue. I think there was a skylight.

She was another Prague refugee and widow. There were three daughters who lived in California. At some point she moved out of the city to live near one of them. When my then eight-year-old daughter and I took a trip to California during

one of her spring school vacations, we stayed with Greta for one night. My mother had arranged it. I agreed to do so reluctantly, sharing my father's reservations. We arrived in our rented car late in the afternoon. I remember a low house on a large swath of green. It was warm, and doors and windows were open, and the sound of a piano came from within. We walked into a room that was a reprise of the Bauhaus-inflected Lexington Avenue flat. It was not what one expected to find in a ranch house in California. Greta got up from the piano and served us tea in thin porcelain cups with rolls and sweet butter and cakes with butter frosting. Later there was a delicious dinner and beds with worn linen sheets. We felt happily cosseted. Greta's hospitality to her friend's daughter and granddaughter was as excessive as her good works in the city had been, but after having been its object, I revised my view of her. My father might have done the same if he had eaten those rolls and slept under those sheets.

MALVA SCHABLIN

Chekhov's *Seagull* begins with this exchange:

MEDVEDENKO: Why do you always wear black?

MASHA: I am in mourning for my life. I'm unhappy.

Chekhov is being funny. He is mocking Masha's pretentiousness.

Malva always wore black, and it was not necessary to ask her why. She was in mourning for her husband, her two children, their spouses, and her granddaughter, who had been murdered at Auschwitz. She had survived. After the war she

came to New York—I don't know how or why—and lived on the West Side with a relative. My mother was deeply attached to her and would see her often; I met her a few times. She never smiled. She was gentle and kindly and indifferent. I cannot say any more.

Movies

Saturday afternoons were spent at a movie house called the
Monroe, on First Avenue between Seventy-Fifth and Seventy-
Sixth Streets, where two feature films, twenty-one cartoons,
a newsreel, and previews of films to come were shown. Kids

went unaccompanied by adults. There was a woman in a white dress called the Matron who walked up and down the aisles and kept us in line. The feature films were black and white (I don't remember if the cartoons were in color or not—I hated them), and the newsreels had a special inky blackness and loud, portentous voices. This was wartime. The war was a given of life, and the newsreels of ships blown up or soldiers under fire made no special impression. It was *King Kong* that scared the bejesus out of me. For weeks after I saw the film, the sound of bongo drums and images of frenzied natives kept me from sleep at night. The scenes of the monster in his jungle-island home, rather than those of him scaling the Empire State Building with tiny Fay Wray in his free hand, were the ones that terrified me. Other films educated me. There was one in which the heroine became pregnant. This had happened, it was clear, because she had sat on the hero's lap. Nothing else (except a standard Hollywood kiss or two) had occurred between them, so it must have been that.

In common with much of humankind, I was infected early on with the virus of romance. As long as I can remember, I was secretly in love with some boy, but it was only in high school that I began to have actual rather than merely imaginary romantic encounters. Boys would ask me out on dates. They were not necessarily the boys I loved. I came to see the power and pity of being the beloved and not loving back. I remember standing on a sidewalk across the street from the high-school building with a boy I had never particularly noticed as he read a speech from a piece of paper about his love for me. It was ridiculous and sad, and my "Let's be friends" answer felt wrong and cruel.

During the summer between high school and college, I had a romance with a fellow student from Music and Art named Arne Lewis. I was seventeen and he was eighteen and we were seriously in love. One of the things I especially loved about him was his completely invented identity as a Spaniard. He was a Jewish boy from Queens, but he had been to Mexico and knew a few words of Spanish, as well as his Hemingway, and this permitted him to create a persona for himself that no girl—unless she was a girl with an advanced sense of the ridiculous, which I certainly wasn't then—could resist. Arne's self-presentation as an exemplar of Spanish pride and machismo was deliciously congenial to me. What is more, I never questioned what was perhaps the most preposterous part of his fantasy. This was the idea that as a full-blooded Spanish male he required huge quantities of sex—but wait!— not from me. I was a nice girl. Nice girls didn't have sex in those days. Arne got the necessary sex from *putas*, whores. With me he maintained the decorum of the time, whereby physical intimacy was limited to kissing and maybe a little breast fondling. It was only years later that the truth dawned on me. Arne was as daunted by and inexperienced in sex as most of the other boys at Music and Art. The Pill and the sexual revolution had not yet arrived. We were all in it together, boys and girls. (Where would he have met the *putas*, for crying outside?) Not all, of course. Later in life I met the writer Leonard Michaels, who had been a few years ahead of me at Music and Art, and I learned that he and a girl named Sue Granville would go up onto the roof of the Music and Art building and screw. I have a memory of Leonard and Sue standing together at the back of an assembly hall. They were both tall and

exceptionally good-looking and looked like beautiful grown-ups. Their apartness from the unformed kids around them was evident and has stayed with me through the years.

Arne and I both had summer jobs. I don't remember, perhaps never knew, or cared, what his job was. Mine was in an accounting firm on lower Fifth Avenue, where I was able to put my typing skills to use. There were no summer jobs that we knew of. The drill was to lie and say you were a high-school graduate looking for permanent work and then quit at the end of the summer. I worked at an oversized office typewriter typing out long lines of numbers. I remember my fellow workers as fat older women. They were kind to me and liked me, and I felt bad when I quit. I didn't exactly tell the truth about going to college, but I think they knew.

Arne and I would meet in the evening and go to the movies or join friends, perhaps to wander around the Village and then eat at a pizza parlor. Incredible as it may sound, pizza parlors were a rarity in Manhattan at that time. It was thrilling to eat pizza, accompanied by Coke. On weekends Arne would come over to my house in the afternoon and we would lie on my bed and kiss. He was tall and lanky and moved in a loping way. I found him terrifically attractive. When I went away to college, we exchanged letters and saw each other during vacations. We broke up during one of the vacations.

He was studying art at Cooper Union. During the summer he gave me an oil painting of his done in the Abstract Expressionist style, which hung in my parents' apartment for many years. It was a dense composition of small pink and red and yellow and white squares. A wag in the family said it looked like headcheese. I thought this was a completely stupid thing

to say about a brilliantly beautiful work. We referred to it as "the Arne Lewis," as one refers to "the Manet" or "the Vuillard." After my mother's death, when my sister and I were emptying her apartment, I proposed that we put it out on the street along with "the Pelc," a watercolor of a black woman in a long pink dress sitting under a palm tree, painted in 1939 by a Czech artist named Antonín Pelc, during a stay in Africa, by way of which he was emigrating to America. My daughter, who happened to be around that day, was calm about the fate of the Pelc, but wouldn't hear of the deaccessioning of the Arne Lewis. Her beloved grandparents' apartment had been her second childhood home, and the painting was somehow integral to its ethos. So it sits in a corner of my basement, quietly enjoying its reprieve, and (perhaps a little nervously) awaiting posterity's verdict.

Skromnost

This snapshot is the only memento I have of a girl I was in love with when I was in my late teens. She is the smiling blonde near the center of the photograph. When I say I was in love with her, I am speaking from later knowledge. At the time—the late nineteen-forties—girls in love with other girls didn't recognize what was staring them in the face. They— we—thought you could be in love only with boys. Lesbianism was something you only heard about. There was a book called *The Well of Loneliness*, a forbidden, rather boring text, from which we formed the idea of lesbians as unhappy jodhpur-wearing daughters of fathers who had wanted sons.

Pat Patrick, as the blonde was called, was small and com-

pactly built, a Jean Arthur type, who radiated a kind of self-containment and forthrightness that contrasted sharply with the wobbly unsureness of the rest of us. The group picture was of the participants in a six-week-long summer program for American and foreign college students run by an organization called the Lisle Fellowship, whose purpose was to make the world a better place through vapid discussions in the evening and volunteer work during the day. How could it not succeed? But, of course, our main interest was in each other, in forming romantic attachments that took hold for a week or so and then petered out. My (unacknowledged) crush on Pat lasted the entire six weeks. I loved the way she strode about the place, as if she were on her way to a meeting of the Council of Landowners. I loved the way she swore. "Christ on a crutch!" "Goodness, gracious, goodness, Agnes!" The word "uninhibited" was in vogue at the time, and I used it in thinking about Pat, envying as well as admiring her for her freedom from the dull conventions by which I was bound. She was nice to me. I was younger than everyone else; I wasn't in college yet. My mother had learned of the program from one of her friends in the do-gooding world, and no one at Lisle seemed to have noticed anything untoward on the application she sent in. I remember Pat counseling me about the boy, Jack, with whom I was going. She didn't like him and I began to see what she meant. I switched to a nicer boy from South America, named Gilberto. Pat was going with someone from France whose name I don't remember, who seemed older and was just possibly worthy of her.

After the summer I saw Pat one more time. In my memory of the meeting she is standing on the sidewalk on Fifth

Avenue across the street from The Plaza Hotel. There is to be a reunion in the Village with some of the Lisle people. It is early evening in late summer. Pat is wearing an elegant dress of dark-blue taffeta with a gathered skirt and cinched waist and suede pumps. Her hair is arranged in a loose chignon at the back of her neck. I had never seen her looking like this before. During the summer she wore shorts and cotton shirts and a ponytail. She looked like everyone else. Now she looks like a socialite, a daughter of wealth and privilege. She is not at ease. She tells me that she has to go to some event with her aunt, with whom she's staying at The Plaza, and won't be able to go down to the Village.

What interests me now in thinking about this last glimpse of Pat is my lack of surprise at her transformation. Of course she would be wearing that dress and those pumps and have an aunt who was staying at The Plaza. The shock was of recognition. We know so much that we don't know we know about each other. We always know each other's class. On some level I had always known Pat was rich and upper-class. Where I belonged in the money and class divide was equally clear to me.

Our family was ordinary mid-century professional middle-class, neither rich nor poor, with no social pretensions. In Prague my parents had been somewhat better off financially and had ties to an advanced intellectual community. A few of their fellow refugees went back to Czechoslovakia at the end of the war to try to resume their old lives. My parents knew almost from the start that they would stay here. This country is so nonchalantly seductive! There is no escaping its wiles. My father was scarcely off the boat when he became a Dodgers fan.

We lived according to our means, on my parents' sala-
ries, with an easy modesty. The Czech word *skromnost* means
"modesty," but it also carries a mild sense of forelock-tugging
humbleness, of knowing one's place. My father worked as a
physician and then as a psychiatrist at the Veterans Adminis-
tration, and my mother worked as an announcer at the Voice
of America. We never borrowed money. The idea of "hav-
ing money," like rich people did, was alien to us. There was
a girl in my class in junior high school named Astrid who
lived on Park Avenue and was considered weird because of it.
Everyone else lived east of Third Avenue, in what was then
working-class Yorkville.

By the same token, I knew that we were a class above the
people who lived in the tenements—we lived in a six-story
apartment building built just before the war—though this
knowledge came to me only gradually. In the earliest years
of my childhood in Yorkville, I had a different idea of the di-
vide between us and the other families in the neighborhood:
I thought we were inferior. I envied the girls their brightly
colored Sunday clothes and their white Communion dresses.
I was ashamed of my mother when she came to school assem-
blies in the clothes she had worn as a professional woman in
Prague, which I thought dowdy and poor compared with the
shiny flower-print dresses of the other mothers. During this
period of social misprision, I made a trade with a girl from
across the street of a beautifully illustrated book of fairy tales
for a comic book. When I proudly showed my parents the
comic book, they humiliatingly made me go to the girl across
the street and get the fairy-tale book back. The parallel be-
tween my trade and the one they had made of Old World

culture for New World vitality was not apparent to them and only now comes into view.

But I want to talk more about *skromnost*, about my family's practice of it and my nostalgia for it. Today we recycle the things we don't want. During my childhood and adolescence and young adulthood there wasn't much we didn't want. It was a culture of conservation. And one of being satisfied with what came our way. The way we live now would have seemed unimaginably posh to middle-class people in the days of millionaires rather than billionaires. Campbell's soup was not associated with Andy Warhol. We ate it. Casseroles of noodles and Campbell's cream-of-mushroom soup were a kind of national dish to serve to company. Does anyone say "casserole" anymore? Rich people ate the cream-of-mushroom dishes along with the rest of us; I've heard of rich old people whose servants still know how to make them. Today, the non-poor eat exquisite food as a matter of course, and four-year-old girls are taken for pedicures. This will be hard for young people today to believe, but no one went for pedicures when I was young. Sometimes for a very special occasion (the end of the world) one had a manicure. It was administered at the hairdresser's while you were under the dryer.

I think of the *skromný* vacations we went on with our parents, in the time between the end of camp and the beginning of school. For several years, we stayed at the Andrews farm, in Pownal, Vermont, which took guests during the summer months, and served wonderful food: corn on the cob, cucumbers and green beans and tomatoes and potatoes from the garden, pork chops and steaks and chicken cutlets from their own or neighbors' animals—what we now call "artisanal"

food. We understood its rare deliciousness. It made up for the monotony of the place. Except for one activity, croquet, I don't know what we did all day. There was a girl named Gwendolyn who cheated at the game: she was always moving her ball or yours. In the evenings we and the four or five other families or couples staying at the farm gathered in the parlor. We played word games or Gwendolyn played the piano. She was pretty in a blond, sugary way. She played well. Marie and I hated her.

There were other summers when my mother couldn't get away from work and my father took us to New Hampshire, to stay in a roadside cabin, one of about eight, owned by a Mr. Hitchcock. Again, I don't remember much about what we did—I think we toured New Hampshire places of interest like the Flume Gorge and Mt. Washington, perhaps we swam in a nearby lake—but I remember the restaurant in a clapboard house across the road from our cabin, a little downhill, that served carefully prepared New England food and gave a special shine to the vacations. We ate breakfast and dinner there and felt fortunate. Here and there you still see collections of cabins on New England roads—I have passed one called Hubby's Cabins, near Great Barrington, Massachusetts—and I think of Mr. Hitchcock and those blurred innocent vacations with my father.

Mother

She had an enormous amount of what used to be called "European charm." My sister and I, each in our way, acquired some of it from her. What is it? From the point of view of feminism, it seems kind of awful, not "enabling" or enabling in the wrong way, the way the first wife in a harem might establish her firstness. By being charming, you are lowering yourself. You are asking for something. I admire the deadpan young women of today who want nothing from you. I like

their toughness and self-containment. Of course, beneath the surface, they are as pathetic as everyone else. But the pose has something to be said for it. My mother wasn't charming in a fluttering feminine way. She was sturdily built and had an affect of enthusiasm and vitality. But she belonged to her time, and this was a time when women worshipped men without ever quite coming out and saying so. It has taken me a long time to understand the implications of her legacy of charm.

My mother was not a "good enough mother," as the psychoanalyst Donald Winnicott put it. She was a good mother. She was warm and loving and unselfish. I remember the incongruously delicious food she made for us when we were ill. One associates gruel and weak tea with illness. My mother made us roast squab and, unbelievably, profiteroles. This may be because she knew we were only malingering; we were allowed to call ourselves ill when the mercury thermometer reached what we called the *křížek*—the line marking the border between normal and elevated temperatures. The border was good enough. When we reached it, we could lie back on our pillows as the phone call to school was made.

My mother had a large nature, but I realize that my idea of it is vague and unformed. As I try to portray her, I come up against what must be a strong resistance to doing so. Let me go back to the charm. Charmers want to know about you, they ask questions, they are so interested. You are flattered and warmed. Sometimes you grow flushed with the pleasure of the attention. I have seen people grow flushed while talking to me. Did I become a journalist because of knowing how to imitate my mother? When I ask someone a question—either in life or in

work—I often don't listen to the answer. I am not really interested.* I don't think my mother was interested in what people told her, either. She asked her questions. But her mind was elsewhere. This is what I can't get hold of. What was she interested in? She was a reader. It was always an article of faith that she, and not my father, was the one who knew what great literature was, that she could always recognize the real thing, that hers was a kind of perfect pitch, while his taste was more commonplace, though he was the literary one, the one who wrote.

Her exuberance and vivacity and warmth were a kind of front for an inner deadness of spirit. She would put herself down. She would say she didn't do anything properly. It's *šmejd*, rubbish, she would say about what she did.

I realized later in life that she always had something the matter with her. We all have something the matter with us—go to any drugstore and you'll see that—but she seemed to suffer more than most from the common minor ailments: muscle pain, indigestion, constipation, headache. At some point during my childhood there was talk about depression and about visits to a Dr. Levine, a colleague of my father's. I have a letter from my father written when I was in college, entreating me to write to her more frequently and saying that she was depressed and felt wounded by my carelessness and callousness. I also have a letter from her written just after

* The use of a tape recorder during interviews permits me to counteract this obvious disqualification for my job. But, thinking about it further, I wonder whether a lot more of us, perhaps most of us, only pretend to be interested in the answers to the questions we ask, and whether the word "empathy" refers to a performance rather than to a feeling.

putting me on the train for college, telling me how much she loved and admired me.

Sept. 15, 51
Darling Janet,

I started to write you a letter just after I returned from the station—it was a tearful letter and disgustingly sentimental. Now, I came back to my senses and I realize how good it is for you to be in a new atmosphere of such a great university. Of course I miss you and somehow I feel that I didn't tell you all the things I wanted. Not advices—I am so sure of you—I am very much handicapped by my poor English—but believe me I have not words even in Czech—to tell you how much I love you and how proud I am of you. You probably have realized that my relationship to you was not entirely the one of a mother towards the daughter, but many times just the other way. I have found in you all the traits of both my parents which I admired and loved so much.

I hope you had a good start and I wish you all the luck. Yesterday—Sunday—we were at the Traubs' cottage—it was a perfect day—lovely swimming and delicious steak dinner. Today back to work and this time I sort of looked forward to it.

So far I found only the brush you forgot and the nylon pants. I also bought a shoe bag for you and I am going to send it very soon.

I expect a letter from you tomorrow—but I want

you to know that I will be quite patient and won't
worry if your letters won't be on the dot. I also
would like if you would write about the things you
don't like just as about those you like—because this
way we will stay sort of closer, don't you think so?

Drahoušku, moc Tě miluji a stále na tebe myslím.

Líbam Tě tvá máma. [Darling, I love you very
much and think about you all the time. Your
mother kisses you.]

"I expect a letter from you tomorrow." Did it come? Did
I write it? Here is what my father wrote in a letter a year and
a half later:

Darling, although we love one another in our fam-
ily as much and as deeply as in any other family/
we may consider our family as an emotional and
intellectual success/, you know that Joan needs
more overt display of genuine emotions and more
affectionate climate than we all other together.
We all probably are in our innermost core the same
or almost the same but we all sort of cover it by
a shell of detachment and occasionally cynicism
or something like that. Mother thrives only in this
cornucopia of abundant warm emotions and we
should give her as much of it as we can, since, if she
does not get it, she is blaming herself and turning
it against herself/ and particularly now, in her age,
she has more tendency to this self blame and self-
depreciation and ensuing depression.

Darling, Joan is a wonderful person, since these

qualities seem to be rare in this century. I am aware that I myself did not always satisfy these needs though I tried my best. I am sure we will all need her one day more than she needs us and we have to do everything to keep her in good spirits and happy. Please, darling, and you are a wonderful girl, too/, write Joan few lines/ non-Gargoylian, with the punch line: love, affection, appreciation, all those feelings you harbor a-plenty but do not express/. Darling, give it a thought. Maybe I am expressing my self in somewhat clumsy way but I am sure you will understand. There are times in our life when we need more emotional support and Joan is just now in such a period of life. Darling, Joan should not know that I wrote you this letter. I am sure you will find your way and form to dispel the clouds and doubts.

"Non-Gargoylian." *Gargoyle* was the college humor magazine I worked on, and in whose "humorous" style my letters home were couched. My parents kept my letters, and when I read them now, I am ashamed and mortified. My mother wanted love and appreciation, and I gave her stupid jokes. How could I have been so cruel and callow? But there may have been another pressure—the pressure to be funny—that was working on me and dictating my awful smart-ass letters. Our family was proud of the way we horsed around and had fun. The "shell of detachment and cynicism" was a style we all liked and cultivated. My father was the dégagé cynic in chief, the most brilliantly humorous of us all, but my mother

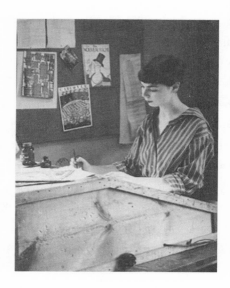

could be funny herself, perhaps more so in Czech than in En-
glish, but she was hardly the simple, warm, affection-starved
woman he depicts in his letter. She participated in the fam-
ily mockery of the Mr. Collinses and Madame Verdurins who
came our way. She didn't intercede for them; her desire for a
"cornucopia of warm emotions" didn't extend that far. I had
gotten mixed signals, and I seem to have resolved the conflict
by ignoring the demands it would have been harder to satisfy.
The fear of speaking from the heart is deep-seated. We form
the habit of defending ourselves against rejection early on.
But, God, what a jerk I was. I can only blush with shame at
those idiotic letters to my lovely mother. What would it have
cost me to tell her that I loved her?

But then I come across a letter that makes me side with
myself against my mother:

Last night she [my sister, then in high school] went square dancing and came home at 1:30. I was absolutely desperate—I don't think I was so scared in all my life. I did not know where she was or with whom—so I was just sitting and waiting and praying and crying. Then she came and was very upset to see me so upset. She simply forgot the time. I am still half dead today. Well, c'est la vie!

La vie with my mother's hysterical iron grip over her children's comings and goings wasn't easy. I remember having to leave parties to meet the curfew and sometimes finding her on the street in front of our building with a coat thrown over her nightgown. New York was fairly safe then—the crime period came later—and we traveled by bus and subway. We didn't drive. What was there to fear? I remember having to leave a party in the Bronx just when a boy I was interested in was beginning to seem interested in me. Flouting my mother's rule was out of the question. I never saw the boy again.

Many years later I won an award from a journalism school for a magazine piece about a family therapist, and I invited my father to the award ceremony. When my name was called, I got up and said thank you and sat down again. I didn't make the type of speech the other award winners had made. I thought those speeches were stupid and sentimental. I felt above them. I didn't realize how stupid and insufferable I myself was, how empty and embarrassing my gesture of purity was. My father said then and a few times afterward that I should have made a speech like the others. One day he said this one time too many and I exploded at him. We were

sitting around the table, at lunch. My explosion was followed instantly by an explosion from my mother. "HOW DARE YOU SPEAK THAT WAY TO YOUR FATHER!!!" A flash of insight came to me. I saw my mother's all-powerful place in the family. The family therapist had spoken of a switchboard that powerful mothers manned. Everything that happened in the family had to go through them. Here was my mother enacting the metaphor. Yes, all happy families are alike in the pain their members helplessly inflict upon one another, as if under orders from a perverse higher authority.

Hugo Haas

This picture always turns up in boxes of old photographs, standing out from the rest in its vivid strangeness. It is a sepia postcard, a successor to the nineteenth-century carte de visite, a relic of early twentieth-century celebrity culture. Hugo Haas was the most minor of celebrities. He was a Czech-Jewish actor who fled Prague in 1939, arrived in New York via France, Spain, and Portugal in 1940, and became a

Hollywood character actor and director of noirish B movies. The postcard is inscribed to my father and shows a man in a tuxedo who seems to be wearing lipstick and eye makeup and looks like one of the *unheimlich* wraiths in *Metropolis* or *The Cabinet of Dr. Caligari*. The photograph shows him from head to mid-thigh, his hands half in his jacket pockets, his slightly pudgy face staring into the middle distance with a small fixed smile.

As a child I would hear my parents speak of Hugo Haas as a fellow émigré, but I have no recollection of meeting him, and I knew almost nothing about him until today, when I looked him up on Google. There I learned about his emigration and his Hollywood career, along with some additional stray facts. One of these was that his wife, with whom he had fled the Nazis, was a woman named Maria von Bibikoff (Bibi), and this has stirred a memory. My parents had a Czech friend named Bibinka, an attractive, slender blonde. Could she have been Hugo's wife? The memory is of Bibinka sitting at our dinner table. We are eating veal paprika. When we finish and my mother is clearing the table, my father notices that Bibinka has left a piece of meat on her plate, and points this out to her. "*Já nemůžu*," she says, "I can't," meaning I'm too full. My father looks sternly at her. That this scene of Bibinka's minor disgrace with my father should have remained with me over a lifetime is a measure of memory's willful atavism. So little is necessarily minor in a child's imagination. My father's upbringing in a poor family was one of the pillars of our family mythology. His active gratitude for having enough was always present to us; it was part of his character. And his reprimand of Bibinka—the reprimand

of a grown-up by another grown-up—must have delighted Marie and me. My mother, on the other hand, could only have been mortified by her husband's outrageous incivility. I imagine that she tried to smooth it over as best she could. But I don't think Maria von Bibikoff, if that's who she was, ever came to dinner again.

The Wikipedia entry on Haas cites the titles of the sixty-five films he acted in and the characters he played, twenty-nine of them in Czechoslovakia and thirty-six in America. I must have seen him in a number of Hollywood films, such as *A Bell for Adano* (1945), in which he played a priest, and *King Solomon's Mines* (1950), in which he played someone named Van Brun. I have heard of none of the B pictures he directed. In the photograph of him on the Wikipedia page he looks nothing like the spectral weirdo on the postcard. He could be any heavyset American male with a bristly mustache and the imperturbable air of a late-night elevator operator at a downtown L.A. hotel. He died in Austria in 1968, from complications of asthma, at the age of sixty-seven. The wife who may have been Bibinka was born in 1917 and died in 2009. The Wikipedia entry also tells us this: "He and his brother, Pavel Haas, studied voice at the Brno Conservatory under composer Leoš Janáček. Pavel Haas went on to become a noted composer himself before he was killed in Auschwitz in 1944."

What I have learned online about Pavel Haas is as bare-bones as my knowledge of his more fortunate brother. But I know one "fact" cited in an article on the website World War II Database—that he "married Sonya Jakobson, widow of Russian linguist Roman Jakobson, in 1935"—to be partially

false. Yes, Haas married Sonya Jakobson, but she was not a widow. Jakobson was very much alive in 1935, and for many years thereafter. My parents would see him when he lived in New York, after his emigration here and before he took up a professorship in the Slavic department at Harvard, where my sister had him as a teacher. I have in my possession a letter he wrote to my father in November 1968 that cheers me up whenever I read it:

> Dear Pepik,
> Your letter, which was handed to me in Prague, was not answered immediately because of all the precarious events that followed.
>
> I am surprised that Zubaty did not know the etymology of *mamlas*,* although such philologists as Matzenauer and Berneker had commented on this word, and, moreover, the etymology seems to me self-evident for any Slavist. Did Trávníček really ascribe a German origin to this word?
>
> The etymology is clear: it is a common Slavic word of onomatopoetic origin, and the root must have been *meml-/mom-*. There exists a whole family of Slavic words closely connected semantically and going back to this root: *Cz. mamlas, mumlati; Kashubian mumlas; Sln. memljati, momljati; SC-mumljati; R mjamlja, mjamlit, mjumlit*. This word family is apparently related to Latvian *memulis*, Lith. *maumti*.

* Roughly: dolt or numskull; the Czech *mumlati*, cited below, means "mumbling."

It would be nice to see both of you, but I hardly
ever stop in New York.

Yours as ever,

Roman

Roman Jakobson

Roman was then married to his second wife, Svatja, whom
my mother disliked. She was another charmer, her public per-
sona perhaps a little too close to my mother's. My mother
considered her phony and ridiculous. There was a mean story
about Harvard having hired her as a condition of acquiring
Jakobson. She taught Czech folklore. I remember her a little,
and I think I know what my mother meant.

I have been fantasizing about the circumstances of Pavel
Haas's marriage to Sonya Jakobson. In 1933, Roman took up
a position at Masaryk University, in the city of Brno, where
Pavel was studying at the conservatory. I imagine the lin-
guist's wife and the composer meeting and falling in love and
the messy divorce and happy marriage of the illicit lovers that
followed. My fantasy recedes before the tragic reality of Pavel
Haas's own divorce from Sonya in 1939, not because of the
end of love, but as a (successful) maneuver to save the non-
Jewish Sonya and their daughter, Olga, from the Nazis. Pavel's
attempts to save himself failed—he could not get out of the
country—and in 1941 he was deported to the concentration
camp Theresienstadt, in Czech Terezín, and sometimes called
a "hybrid ghetto/concentration camp." There were no gas
chambers; inmates merely died of starvation and disease—
those of them fortunate enough not to be immediately sent

on to Auschwitz, for which Terezín was a way-station. The Wikipedia entry on Pavel Haas ludicrously notes that "on his arrival at Theresienstadt he became very depressed and had to be coaxed into composition" by a fellow-composer inmate. Theresienstadt is known for the Potemkin village the Nazis made of it for a Red Cross visit in 1944, presenting it as a kind of resort and cultural center. After the gullible visitors left, the obscene masquerade was dismantled, and eighteen thousand inmates, Pavel Haas among them, were deported to Auschwitz.

I recently met a fellow Czech-Jewish émigré named Zuzana Justman, who came to this country in 1950 at the age of nineteen to study at Vassar. Her family did not have the good fortune mine had. She and her brother and mother and father were unable to get out of Nazi-occupied Prague before the vise closed, and were sent to Terezín in 1943. The father was one of the eighteen thousand deported to Auschwitz after the Red Cross visit; he was killed in the gas chambers upon arrival. Zuzana, her brother, and her mother remained at Terezín and survived. I asked Zuzana if she had known Pavel Haas there and she said no. But she had once met Hugo. In the early fifties, when she was in her early twenties, she and her mother visited California and met Hugo for lunch in Hollywood. Her mother was excited about the meeting. She said that Hugo was one of the most charming and witty people she had ever known. She knew him before her marriage to Zuzana's father: she had *flámovat*—gone out to nightspots—with him. He was one of the most famous and well-regarded actors in Prague. But Zuzana did not find the middle-aged man she met in Hol-

lywood the least bit charming and witty. She was repelled by
a tasteless story he told about his sexual exploits with Holly-
wood starlets. He seemed sad and depressed.

Zuzana, who herself is charming and witty, became a film-
maker later in her life. She had intended to be a dancer, but
a foot injury intervened. She is known for two documentaries
about Terezín, *Terezín Diary*, released in 1989, and *Voices of
the Children*, released in 1998. She recently sent me the an-
nouncement of the 1952 Writers Guild of America Award
for Best Written American Low-Budget Film, which Hugo
received for a picture called *Pickup*, in which "a young woman
(Beverly Michaels) marries a middle-aged man (Hugo Haas)
and then plots to take his money."

More on Mother

I have been reading—not happily—letters that my mother wrote to me in the nineteen-fifties. I am pained by the "Why haven't you written?" motif that runs through so many of them. I am pained both for her and for myself. It must have been bitter for me to be constantly reproached for my exercise of the prerogative of youth to be careless and selfish. But what I see now that I didn't see then is that her need for letters from me was a kind of sickness, like the sickness of being in

love, and since I was in love all the time myself, I might have seen her as a fellow-sufferer rather than as an adversary whose thrusts I must parry to protect my wobbly independence.

My mother was temperamental. She was volatile. She could fly off the handle. We—my sister and I—knew this about her and didn't take it seriously; she was never unkind to us. She certainly never abused us. She just allowed herself her histrionics. One of the reproachful letters—"It's two weeks since you wrote—thank god we have the Daily and found a story written by you. I don't see why you could not find 2 minutes to write home"—ends with the outburst "I am too mad to write more." In another letter—for once not on the why-don't-you-write theme—she tells of a lucrative job offer at Radio Free Europe she turned down and lashes out: "Everybody thinks I am an idiot—but I simply don't feel like working and nobody can force me."

I remember a scene in which she packed a suitcase and said she was leaving. She had had enough. In the scene, Marie and I and my father are watching her pack the suitcase. She seemed to mean it, but I don't remember any feeling of distress. I think we all knew that this was farce of some kind. Of course she didn't leave.

I think the issue was my grandmother, my father's mother, who lived with us. Something about the threads and pins from her sewing that were always all over the floor. My grandmother was a kindly, well-meaning woman who was a great trial to my mother. It is rare for wives to happily welcome their mothers-in-law into their households, but this mother-in-law must have been particularly hard to live with precisely because of her harmlessness and kindliness—and depression.

In a document titled "My Confession," Babička, as we called my grandmother, writes of her miserable childhood as the un-loved thirteenth child of parents who sent her to live with a married sister, who mistreated her. The grim childhood ended with a loveless arranged marriage that ended in di-vorce when my father was an infant. Babička's "Confession" puts me in mind of Chekhov's stories about brutal peasant life and of his spare recollections of his own childhood as the son of a serf who caused him to wonder every day whether he would be beaten. Somewhere Chekhov wrote about hav-ing to squeeze the serf out of himself. I have wondered how my father squeezed the serf out of himself, my witty, erudite, kind, unselfish, gentle father. The vestiges of his peasant childhood—his personal parsimony (he was generous toward

others), some kind of lack of Hapsburg polish that annoyed my mother—were insignificant, though my sister and I may have sided with my mother in the airs she put on. We always knew he came from a village and she from a Prague apartment with Art Nouveau wallpaper.

I don't want to exaggerate my mother's attachment to refinement. She had an earthiness of her own that her temperament and temper expressed, and she was never cruel to my grandmother. She just got fed up from time to time. We all felt guilty about my grandmother. I learned only later that she was clinically depressed and received shock treatments, and that they helped. I don't know where she received the treatments. It could not have been in my father's office at our apartment, where—yes, this is true—my father (assisted by my mother) gave shock treatments to some of his patients. This was actually allowed in the nineteen-forties.

Fred and Ella Traub

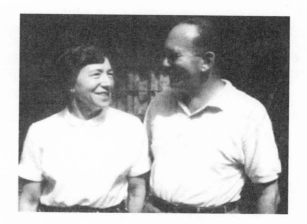

They were close friends of my parents' and fixtures of my sister's and my childhood, a childless couple, Czech Jews, physicians, who had spent the war in London and then emigrated to New York. Someone brought them to the attention of my parents, who helped them get settled—she as an internist in private practice, he as a bacteriologist in a hospital in Brooklyn—and found them an apartment a floor above us in the building on East Seventy-Second Street where we lived on the ground floor. They were modest, kind, good people who brought out an obnoxiousness in my sister and me for which I would blush today if I were a better person. But a child's cruelty is never completely outgrown; the Traubs'

status in my imagination as the epitome of dullness remains to shame—and to cheer—me. Of course we behaved perfectly nicely; the Traubs never suspected how we felt about them. But recognizing dullness for the dispiriting thing it is may not be a bad part of one's early education. It can only make the glamorous, the hilarious, the sexy, the strange more precious.

This scene occurred almost every day: We would sit down to dinner in an alcove outside the kitchen called "the dinette." These small non-rooms were part of a fashion, beginning in the thirties, to daintify domestic life among middle-class Americans who presumably didn't want to eat in the kitchen the way rich folks don't, but couldn't afford living quarters with a dining room. A few minutes into the meal, there would be a knock on the door, and then one or both Traubs would appear. My parents would urge them to sit down and eat with us. No, no, we just came by on our way home from work. Then they would stand, hovering, as we tensely ate. We all hated it, but there was nothing we could do about it. The dinette was near the entrance to our apartment, so that the Traubs stood just inside the front door, which somehow only added to the tension, because the possibility that they could leave at any moment was so tantalizingly present—yet so far from happening for so long a time.

The Traubs' apartment, in contrast to them, did hold a certain glamour for me, as did the exotic breakfasts that they had learned to eat in England, and which I sometimes glimpsed. There were cheeses and slices of ham and rolls and breads and sweet butter and orange marmalade. In the living room, furnished much the way our living room was, in a mildly modernist European fashion, there was a pewter covered dish always filled with some kind of dried, salted bits

FRED AND ELLA TRAUB 85

of things to nibble on. We never had anything like that in our living room. The Traub living room seemed more elegant than ours, and the covered dish added to its charm.

I've remembered something unpleasant about Ella, something I suppose I have not wanted to remember. She was a general practitioner, but her specialty had once been gynecology, and Marie and I were sent to her for gynecological examinations. In the best of hands the large, heavy metal instrument called a speculum is not a pleasure to feel inside yourself. In Ella Traub's hands it was torture. Those examinations were awful. We struggled against her; we brought out the worst in this woman, who was so kindly and mild, and her frustration at our wincings and cryings out only added to her clumsiness. Enough about that. She was a beloved doctor in the Czech neighborhood. Her waiting room—a long corridor—was always full of patients who waited and waited.

She was plain, with pale-blue eyes; Fred, I see from the picture, was dark and more attractive, but as a child I made no distinction between them. They were equally dreary. He always knew where to get some appliance cheaper than elsewhere. He died of a heart attack well before his time, as people did then. Ella stayed on in the apartment and remained a fixture in our family life. At some point, under my father's (misguided?) guidance, she began practicing psychotherapy.

As I prepare to tell the story of Ella's later life, I am struck by the characteristic disparity between the dramatic character of the stories we hear and tell about people we know and the prosaic character of the people themselves. In literature interesting things happen to interesting people; in life, more often than not, interesting things happen to uninteresting people.

Ella had a friend named Olga Demant. She was the wife of a Czech dentist, Frank Demant, whom Marie and I had briefly gone to and whom, like other dentists of our childhood, we had feared and despised. He wasn't as bad as the dentist— I think his name was Logan—who pulled the tooth in my mouth *next* to the tooth he had meant to pull, but he was bad. Olga was a retired opera singer, whose stage name was Olga Forrai. Frank died, and Olga and Ella became friends in their widowhood. Olga, as I remember her, was a large, dark, fat, willful woman. She became a friend of my mother's as well as of Ella's, and at some point, I don't know why, she gave my mother two sets of wineglasses, which my mother promptly gave to Marie and me. (My mother didn't like Olga, but Olga wouldn't hear of being shed.) I still have—and treasure— Olga's gold-rimmed wineglasses. In what could be called an act of anti-alchemy, I have deliberately allowed the gold to wear away by putting the glasses in the dishwasher. The traces of the gold please me, where the solid gold rims had too much of the atmosphere of the heavy rich woman they came from.

Now I will tell the story within a story of how Olga was cruelly deceived by a young homosexual named Grover who insinuated himself into her life, living in her apartment and "taking care" of her finances. One day he disappeared, with all her silver and her money. He was found in Florida and arrested, but Olga refused to file charges. She loved him too much and forgave him. She died soon afterward.

It turned out that Olga had been a singer of some stature, and a foundation was formed in her honor, of which Ella became an active trustee. Much of Ella's later life was taken up with the Olga Forrai Foundation, which gave scholar-

ships to aspiring singers and conductors. At the foundation she met two people, a man and a woman, who were to play a momentous role in her life, or perhaps more to the point, afterlife. The man was a lawyer, and Ella put him in charge of her estate, firing the upright attorney who had for decades served in that role. The woman (unknown to Ella) was the lawyer's mistress and accomplice in the scheme that robbed Ella's heirs of their inheritance. Ella wasn't rich, but she had lived frugally and there was some two million dollars in the bank at the time of her death, in 1996, along with valuable objects and paintings in her apartment. She died miserably, of cancer, her frugality robbing her of the comfort of proper full-time care; there were only inadequate brief visits from hospice aides.

Ella's natural heir was a woman named Linda Vlasak, another Czech émigré; she and her husband, George, were the childless Traubs' "children," so to speak. They were a short, cheerful, droll pair. They lived in Baltimore; Linda worked at the Johns Hopkins Press as an editor, and George was a professor at the university. By the time of Ella's death, George had followed Fred to the grave. There seemed no doubt that Ella's money and the contents of her apartment would go to Linda. But when the will was read, it turned out that Linda was only one of eight people among whom Ella had divided her estate. My mother was another, and I remember that she was outraged as well as puzzled.

The surprise of the will was followed by the news that there was no money to distribute: the lawyer had taken it all. This was followed by the discovery that the contents of Ella's apartment had been carted away and presumably sold by the evil

attorney. I remembered that on a visit to her during her last illness I had admired her collection of vases by the Art Nouveau designer Émile Gallé, and she had said, "Why don't you take one of them?" Of course I had refused, but now I wish I hadn't so automatically followed my good upbringing. It was horrible that no trace of Ella remained, that the nineteenth-century paintings, the small modernist sculptures, the Persian carpets, and the covered pewter dish were all irretrievably gone.

The years went by. The lawyer was caught and jailed. Some small amount of money was extracted from him and restored to the heirs. Linda and George's daughter, Marian, who had gone to West Point and become a lieutenant colonel, retired and moved to a farm in Kansas with her husband and son; Linda accompanied them and became the indispensable grandmother. We would receive her amusing, tart letters at Christmastime.

THIS IS NOT THE END OF THE STORY. On November 20, 2008, Linda received an email with an attachment from a stranger who identified himself as

> Ken Strauss, an American physician working as European Medical Director in Belgium. I am also a published novelist, hence this mail. Through Dr. Jarslav E Sykoral, NY head of SVU, I received a PDF of the obituary you wrote in 1996 on Dr. Ella Traub, an escapee in 1939 from Nazi overrun Prague and, for most of her professional life, a remarkable Czech-American physician working in Manhattan.

> I am attaching the first draft of the Introduction to
> a book Dr. Enzo Costigliola (President of the Eu-
> ropean Medical Association) and I are considering
> writing on Dr. Traub. It will explain the unusual way
> in which we were drawn to her and to this project.

The way was unusual indeed. One afternoon in Decem-
ber of 1996, Dr. Costigliola was walking past an apartment
building on the Upper East Side and saw "an immense pile
of books, papers, clothes, furniture—thrown there pall-mall
[*sic*]—all lying on the sidewalk and in the gutter waiting for
the dump trucks." Costigliola's eye was caught by a folder,
which he plucked from the pile and in which he found letters
and papers—some in English and some in a language he did
not recognize—that had belonged to a woman named Ella
Traub. He took the cache home and from time to time dream-
ily read a letter or two, but told no one of his find. Though "the
intrigue never faded," twelve years went by as the folder sat in
his office "gathering dust." Then, in 2008, during a meeting
with Strauss, Costigliola impulsively produced the folder and
told his friend about the incident. Strauss's response was to
go to a computer and type "Ella Traub" into Google, which
immediately produced the obituary Linda had written. "Enzo
was speechless," Strauss writes. "He never thought of search-
ing through the internet. In the first five minutes I'd found
out things he'd wondered about for more than a decade."

The first page of the seven-page Introduction, written by
Strauss and titled "The Discovery of Ella,"* shows a photo-

* An amended version of "The Discovery of Ella," edited to correct errors
identified by Linda in the original (see below), appears on Ken Strauss's

graph of a woman under the caption "This is Ella." On page 2, Strauss notes that the picture was taken in 1940, when Ella would have been twenty-nine, and goes on to describe her:

> She has clear, bronzed skin, a high forehead, almond eyes with thick brows and a luxuriant head of wavy hair. She wears a lacy blouse with a pendant clasp. It fits snugly over round shoulders and her full female figure. She has a mole on her left cheek and her eyes look over the shoulders of the photographer, searching and fetching. The lips are thin and aquiline, perfectly painted. She is a beautiful young woman, sensual and intelligent.
>
> She is how I imagine Anne Frank might have looked had she been allowed to live.

He goes on to show another photograph, taken twenty years later: a group picture in four rows of the house staff of the Jewish Hospital of Brooklyn. There are two women among four dozen men in the picture. One woman, sitting in the back row, "looks Philippine," Strauss writes, so Ella must be the woman in the fourth row—"looking pouty and tired, with her hair cut bushy short"—who is standing next to an extraordinarily tall and handsome man, who must be Fred Traub.

From Linda's obituary Strauss learns that Ella treated some distinguished members of the Czech exile community in New York, among them Alice Masaryk, the daughter of

blog; I am writing here about the original version Linda received from Strauss.

Tomáš Masaryk, the first president of Czechoslovakia, but that "most of her patients were ordinary people." He commends Ella for practicing medicine in the "old fashioned" way, not charging patients too poor to pay, working from a home office, and making house calls. He thinks of the prospective book as a tribute to an ideal, now lost, of medicine as it should be practiced and life as it should be lived. At the end, he returns to the Anne Frank theme—"She was the Anne Frank who survived—a young woman who had the instincts to see what was coming and the courage to leave just as her career was set to take off. She escaped Hitler's grasp just in time."

Linda replied to Strauss in her characteristic crisp manner. "I'm sorry to tell you that the imaginative interpretation of Dr. Costigliola's photographs, as proposed for the opening of your first chapter, will not do. The portrait is not of Ella, but Anna Wiley, Italian wife [of] Fred Traub's cousin Charlie Wiley (Czech name: Karel Weil). In 1940 she would have been about 20 years old and still living in Italy, from where she immigrated to the U.S. only after the war, if I remember it correctly. I met her at the Traubs many times and kept in touch with her until about 1998. As to the group photograph of the JHB House Staff, I have to disappoint you as well. Ella is not among the group, because she was not on the JHB staff in 1960, and the woman misidentified as Ella is unknown to me. However, Ella's husband Fred is in the picture, seated in the front row center, seventh from the left."*

* The photo caption has been altered in the online version to reflect these corrections.

Linda goes on to caution the prospective authors about their use of the found documents:

> Ella's estate was the subject of an extended and complex litigation, and the lawyer named by Ella in her will as the sole executor ended up serving a term in jail because of his neglect, theft and mishandling of the property. The moment when Dr. C picks up some letters from the gutter in front of the house at 405 East 72 Street,* where Ella lived and died . . . strikes me almost like an act of Divine Providence. But I would consult the law firm that was in charge of cleaning up the mess to make sure that the "found and rescued" documents would not be considered "stolen property" and belonging to the estate. In any case, as one of the surviving beneficiaries named in Ella's will, I would claim the privilege to examine these papers before releasing them for publication.

I don't know whether Linda ever got to see the papers. I gather that "The Discovery of Ella" never saw print.

Following Strauss's example, I have gone to Google and looked up the two men, as well as the mysterious European Medical Association they belong to. Strauss is described as a

* Adding to the baroqueness of this story, there is some confusion about the location where Dr. Costigliola made his find. In "The Discovery of Ella," he recalls it taking place at 1 East Ninety-Third Street; however, he must be misremembering: there is no doubt that Ella Traub lived and died in the apartment building on East Seventy-Second Street that Linda refers to (and where my family lived). "The Discovery of Ella" also alludes to the Traubs living at 205 East Eighty-Second Street, but this was an earlier address.

physician/author and the owner of a manor on the French-Belgian border called Le Château du Jardin, to which physicians and nurses with literary, artistic, or musical aspirations may apply as artists-in-residence He published a novel called *La Tendresse* with Black Ace Books of Forfar, Scotland, and two other novels online. He has also published scientific papers in the field of endocrinology. Dr. Costigliola appears as a medical man who has held many official positions, among them chief of medical services of the Italian navy.

The European Medical Association remains opaque.

DISCUSSION

QUESTION: What is the point of this story?

ANSWER: That interesting things happen to uninteresting people.

QUESTION: That is repellent. Who are you to say who is interesting and who is uninteresting?

ANSWER: You're right. That's a completely fair rebuke. I am ashamed of myself.

QUESTION: Your parents were good friends of Fred and Ella's. And yet they communicated something to you and your sister that emboldened you in your snottiness toward them. You need to untangle the knot of this contradiction.

ANSWER: Yes, my parents must have given us permission to look down on the Traubs. They allowed us to overhear them making fun of their gaucheness. But they only let us vaguely

grasp the important thing: namely, the strength and genuineness of their bond with Fred and Ella. In Prague they had moved in different circles, but here they were fellow refugees, facing the same strangenesses, suffering from a similar homesickness. The Traubs' *nekulturny* ways were insignificant compared with the comfort of their Czechness. My parents had come to America to sit out the war, but when the war ended they did not go back. They had immediately taken to America, but, paradoxically, not to Americans, who remained somehow alien. During the nineteen-forties their friends were other Czech émigrés, first and foremost the in-house Traubs. American friends came much later. It has taken me three-quarters of a century to figure this out.

I remember a story my mother told about an early brush with American alienness. She was at a dinner in an American household. The time for seconds arrived. When my mother was offered the platter, she declined. This was Prague etiquette. A charade called *nutcení* had to be performed. The hostess would press you to take another helping, and, after many demurrals, you finally gave in helplessly to her urgings. But here "No, thank you" was taken to mean just that, and the platter of delicious American food was whisked away before my mother's sad eyes.

QUESTION: What about those Gogolian doctors? They are comical, but do they belong in this memoir of your childhood?

ANSWER: I'll make a stab at fitting them in. They evoke the absurdism that ran through our family life. My father was the absurdist in chief. There was something called Dada that we didn't know much about but that was a model of irreverent wit. "The Discovery of Ella" would have delighted my father, and my mother too, who played the role of protesting kind,

bland mom but recognized ridiculousness when she saw it and could be meanly witty herself.

QUESTION: What about Linda Vlasak, who loved the Traubs and did not find them dull? Does the thought of her reading what you and Marie felt about them—and the implication of your parents in this arrogance—bother you?

ANSWER: It certainly does.

Francine

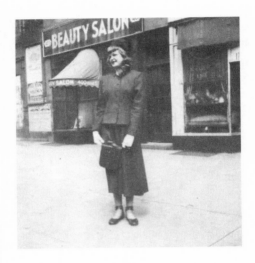

There was a girl in junior high school named Connie Munez who was like the heroine of a fairy tale: preternaturally beautiful, extraordinarily kind, and without much character. The rest of us—this was a girls' junior high school—paid court to her, flocked around her, vied for her attention, which she dispensed generously and indiscriminately. She had pale skin and black hair, rosy cheeks, and a lovely smile. It was a long time before I realized how bland she was. I'm not sure why her image and my idea of her as uninteresting have stayed in my memory.

My bad-girl friend Francine Reese has a stronger grip on

my retrospective imagination. We became best friends against my parents' wishes. Somehow they knew of her reputation, and there may have been something they knew and didn't like about her parents. We would walk home from school together, sometimes stopping off at a candy store on York Avenue to share a malted milk shake and a pretzel. Candy stores in those days were cramped dark places, like shoe-repair stores, where penny candy, newspapers, and odd items called "sundries" were sold, and ice-cream sodas and milk shakes were prepared by the testy but good-hearted owner. The man who made our milk shake would unerringly dispense exactly the right amount of milk, vanilla ice cream, chocolate syrup, and malt to fill two glasses to the brim after the machine had performed its noisy tour de force. I have a memory of Francine looking up from her glass, as if emerging from an altered state, and saying, "It tastes so good." That these unremarkable words should have stayed in my mind while more significant utterances have disappeared is another instance of memory's perversity.

Francine was always in trouble at school. She had in her the spirit of defiance and rebelliousness. I no longer know, if I ever did, what she got into trouble about. But I had one indelible experience of being pulled into her orbit of rule-breaking chaos. I myself was a "good" girl, though not an especially good student, and in my attempt to please my parents without going to the trouble of serious academic effort, I went in for worthy-sounding extracurricular activities. One of these (it may have been an appearance on a radio program of students inanely holding forth on "current events") led to an invitation, extended through the school, to join an idealistic organization

called the World Friendship Council of the Future and to attend an upcoming reception. I naturally accepted the invitation, but had the terrible idea of bringing Francine with me to the reception.

It was held at a fancy Park Avenue apartment, and the scene, as I remember it, was the apotheosis of Park Avenue wealth and stuffiness: elegantly dressed people sitting on antique sofas and chairs; maids in uniform passing delicious-looking canapés; the hum of low, cultivated voices. For Francine, of course, this decorum was only another opportunity for disruptive mischief. She ran about, laughing, upsetting things, poking into places not for guests to poke into. But she didn't run alone; she took me with her as a helpless accomplice. I have a geographic memory of the occasion—a room with guests and maids and canapés clustered at one end and an unoccupied area at the other that Francine, with me in tow, had appropriated for her fun and games. I would have preferred sitting on a velvet sofa at the party proper, sucking up to the rich grown-ups, and eating the delicious canapés. But I had brought Francine and there was no question of abandoning her. I was like the refined young man who inadvertently finds himself in good society with his coarse mistress but refuses to pretend he doesn't know her. I knew I had made a blunder, but didn't regret my loyalty to my friend; my chief regret was having to forgo the canapés.

Some weeks later a letter came to me at school. It surfaced a few years ago in a box of family papers, and I have it before me now. It is typewritten on the stationery of an organization called World Festivals for Friendship, Inc., and bears the signature of its executive director, a woman named

Gerda Schairer, and the initials of the person to whom it was dictated. The date is April 10, 1947. On the left side of the stationery there is a long list of "World Friendship Sponsors," among them Fiorello La Guardia, Rockwell Kent, Lily Pons, Fannie Hurst, and Thomas Mann. The letter reads:

Dear Friend,

As I asked Dr. Turner to choose a few new members for the World Friendship Council of the Future to substitute for the members who had left town, I guess he misunderstood me and chose some children, who we feel are too young to take part at such meetings as are held by the World Council of the Future.

You were kind enough to be present at two meetings, but we feel that it may be better if you would discontinue your visits in the future and perhaps later on in two or three years' time you may get more pleasure in joining such a group.

You and your friends are most welcome to attend the celebration of The World Friendship Day on May 8 as a member of the audience. Please let us know if you and your friends intend to be present and we will be glad to send you invitations.

I can imagine the mortification this letter brought me. I feel for the girl who had to read its cruel, punishing words. At the same time, I have to smile at the ghost of Francine that emerges from the angry text and has a kind of last laugh. To get so deeply under the skin of a grown woman as to make

her forget her grown-upness and reduce her to a spiteful child lashing out at another is no small feat.

I am struck by a phrase in the letter—"you were kind enough to be present at two meetings." So it appears I had been to the ritzy apartment once before the disastrous visit. Pre-Francine, I had done it right; I had ingratiated myself with the illustrious guests and tasted the delicious canapés. A second invitation had followed and, had I not brought Francine, there would have been a third and a fourth. Who knows, I might still be going to meetings of the World Friendship Council of the Future.

Francine and I went to different high schools, and the friendship came to a natural end. Over the years, other bad girls entered my life. I was attracted to them for their rebelliousness, and I suppose they were attracted to me the way certain gay men are attracted to straight men in whom they sense—with or utterly without reason—a glimmer of hope of conversion. I never became genuinely bad, but while in the subversive company of these girls I was able to surmount some of my native goody-goodyness. (Wartime America had provided particularly fertile soil for it.) Francine's interest in me may have held an element of wistfulness as well, perhaps even of envy. I lived in one of the new apartment buildings on the block, while she lived in a tenement; her father was working class, mine was a doctor. There was something tormented and driven in her manic behavior; she may have suffered abuse at home. I don't know what became of her, or of Connie. Francine may remember me. I doubt that Connie does.

Lovesick

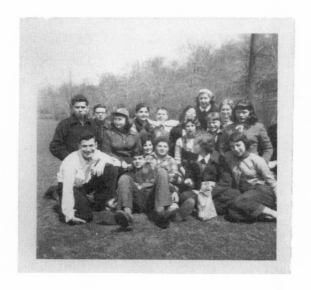

There is a box in my apartment labeled "Old Not Good Photos." This is an understatement. Most of the photos are two-and-a-half-inch squares, showing little blurred black-and-white images, taken from too far away, of people whose features you can barely make out, standing or sitting alone or in groups, against backgrounds of gray uninterestingness. They are like the barely flickering dreams that dissipate as we awaken, rather than the self-important ones that follow us into the day and seem to be crying out for interpretation. However, as psychoanalysis has taught us, it is the least

prepossessing dreams, disguised as such to put us off the scent, that sometimes bear the most important messages from inner life. So, too, some of the drab little photographs, if stared at long enough, begin to speak to us.

A picture of seventeen high-school boys and girls, sitting on the grass and mugging at the camera, takes me to a deep blue sky punctuated by the silhouettes of minarets. I have never been to the Middle East. The memory of the minaret-studded sky comes from a movie house called Loew's 72nd Street, where I saw many movies in my childhood and youth and where one of the boys in the picture, Jimmy Scovotti, worked as an usher on weekends. Before the house darkened and the movie came on, one sat in a kind of Orientalist dream. The interior had been done up as an *Arabian Nights* palace. I don't remember being especially thrilled by it—Loew's 72nd Street was not the only movie house where this sort of entertainment was added to the celluloid entertainment—but I enjoyed it as I enjoyed the other now preposterous-seeming amenities of the nineteen-forties. It was my first encounter with the clichés that Edward Said's great book held up to view.

I don't recognize any other boy in the photograph. I only recognize a girl named Nathalie Gudkov and myself. I know the picture was taken on an outing to a place in Yonkers called Tibbetts Brook Park, but I remember nothing about the outing itself, or why I was there. I know these were kids I did not have much to do with in high school. None of the boys were the ones I was in love with during those years. As I write the words "in love," the picture—I was about to say dream—begins to speak, a bit too fast, about the habit of love

we form in childhood, the virus of lovesickness that lodges itself within us, for which there is no vaccine. We never rid ourselves of the disease. We move in and out of states of chronic longing. When we look at our lives and notice what we are consistently, helplessly gripped by, what else can we say but "me too"?

In "Observations on Transference-Love" (1915), the third in a series of papers on analytic technique that formed a sort of operating manual for analysts in the early days of the profession, Sigmund Freud alerted new practitioners (almost none of whom were women) to one of its occupational hazards. Women patients, he warned, are going to fall in love with you, but don't think that this is "to be attributed to the charms of [your] own person" or that it is real love. It is a peculiarity of the treatment, a form of resistance to it. Whatever you do, don't reciprocate, but see what you can do about persuading the patient to stick out her lovesickness and remain in the analysis, which will eventually cure her of the problems with love that brought her to it in the first place. The analyst

> must take care not to steer away from the transference-love, or to repulse it or to make it distasteful to the patient; but he must just as resolutely withhold any response to it. He must keep firm hold of the transference-love, but treat it as something unreal, as a situation which has to be gone through in the treatment and traced back to its unconscious origins and which must assist in bringing all that is most deeply hidden in the patient's erotic life into her consciousness and therefore under her control.

Freud goes on to spell out the difference between transference-love and "genuine love." He argues that if the patient were truly in love with the analyst, she would try to help him with the treatment rather than try to sabotage it. And "as a second argument against the genuineness of this love we advance the fact that it exhibits not a single new feature arising from the present situation, but is entirely composed of repetitions and copies of earlier reactions, including infantile ones."

Then Freud makes one of the sly rhetorical turns by which his work is marked and that give it its special potency. He anticipates the reader's objection to what he is saying by agreeing with it: "Can we truly say that the state of being in love which becomes manifest in analytic treatment is not a real one?" No, we can't. "It is true that the love consists of new editions of old traits and that it repeats infantile reactions. But this is the essential character of every state of being in love." He goes on:

> Transference-love has perhaps a degree less of freedom than the love which appears in ordinary life and is called normal; it displays its dependence on the infantile pattern more clearly and is less adaptable and capable of modification; but that is all, and *not what is essential*. [Italics mine]

Freud ends the paper by returning to his admonitions. Yes,

> sexual love is undoubtedly one of the chief things in life, and the union of mental and bodily satisfaction in the enjoyment of love is one of its culminating

peaks. Apart from a few queer fanatics, all the world knows this and conducts its life accordingly.

But the analyst must stand firm against the temptation to return the patient's love. He adds:

> It is not a patient's crudely sensual desires which constitute the temptation. . . . It is rather, perhaps, a woman's subtler and aim-inhibited wishes which bring with them the danger of making a man forget his technique and his medical task for the sake of a fine experience.

A fine experience. If we read "Observations on Transference-Love" with the evenly hovering attention with which the analyst is taught to listen to the patient's monologues, we are struck by the language that Freud allows into his scientific paper, the language of ordinary life lived in pursuit of erotic experience. It is Freud's honesty that rises above his ambitions as a scientist and forces him to acknowledge that this thing called transference-love is a pretty wobbly notion, if not a cover-up for the attraction that develops between a man and a woman who meet every day in a small room and talk about intimate things while one of them is lying down. The concept of transference, the idea that we never see each other as we "are" but always through a haze of associations with early family figures, is the matrix of psychoanalytic therapy. The analyst draws the patient's attention to what he doesn't notice in regular life, to the stale old drama he feels compelled to play out with every new person. He proposes an alternative script to this comedy of misprision. But Freud acknowledges—and never with more

rueful force than in "Observations on Transference-Love"—
the enduring injuries of our hapless earliest erotic encounters.

At the time of the Tibbetts Brook Park outing, I had, of
course, not read Freud's paper, and would not read it for many
years. But another text on abstinent love was well known to
me: a bestselling novel called *Seventeenth Summer*, by Mau-
reen Daly, first published in 1942, chronicled the summer ro-
mance of a seventeen-year-old girl named Angie Morrow and
a boy named Jack Duluth who lived in the Wisconsin town
of Fond du Lac and never did anything more than kiss. Re-
reading the book years later, I recognized it for what it was—a
tract for the repressive sexual ideology of the time, whereby
nice girls didn't "go all the way" and nice boys hardly ex-
pected or wanted them to, given their own nervous-making
sexual inexperience. But in its day the book only encouraged
underinformed teenage girls like me in our longings for sex-
less romance, and never disturbed the curtain of humorless-
ness through which so much of postwar American reality was
filtered. When Angie recalled her first date with Jack, on a
boat—remembering "how much he smelled like Ivory soap
when his face was so close to mine"—we did not laugh. How
else should a boy worthy of love smell?

The metaphors of cleanness vs. dirtiness form the book's
understructure, instantiate its opposition of purity vs. cor-
ruption. Whenever Jack appears, Angie, who is no slob
herself—she is always ironing or making beds or drying
dishes—immediately and happily notices how much cleaner
he is than any other boy. ("His shirts always seemed clean
when other fellows' were warm and wrinkled.") The dirty act

of sex is represented by nature, by the dark, muddy water and slimy weeds of the lake and trees,

> bent low, twisting and moaning, wrenching at their trunks and writhing in a strange sympathy with the tormented water. Gray waves rolled crashing toward the shore and thrashed against the wooden pier, slapping like bare hands against the flat rocks. High sprays of foam tossed into the air and the wind was heavy with the damp, suggestive smell of fish.

Lest the reader allow the suggestiveness of the nature passages to lead her, even just in thought, from the sex-fearing straight and narrow, Daly introduces a cautionary subplot involving Lorraine, Angie's sister, who isn't beautiful and natural the way Angie is—she is always putting her hair in curlers and covering her face with cold cream—and who, in her desperation to keep him interested in her, succumbs to the demands for sex of a "fast," unpleasant, older (in his twenties) guy named Martin. We never learn whether the ill-favored Lorraine went all the way with Martin, or just allowed him the liberties then known as "petting" or "heavy petting." "Things are different now from the way they used to be," Lorraine defiantly says to Angie during the confessional scene in which we learn of her transgressions. "Now *everybody* does it and nobody thinks . . . you know what I mean . . ." But later she piteously admits, "This isn't how I meant to grow up. I've heard of other girls . . . but that isn't how I meant to be."

Daly's tale of careful love is still in print. Among the responses to the book on Amazon, my favorite is from a reader

in her twenties who just bought a copy for an eleven-year-old and isn't sure how the gift will be received: "For an 11-year-old girl that daydreams about kissing boys, she'd probably like it. For an 11-year-old girl that's already had sex, the book may seem 'lame.'"

Atlantic City

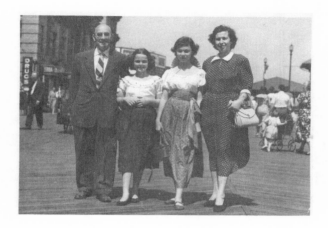

The picture shows my father and mother and Marie and me
standing in a row facing the camera. Stamped on the back of
it are the words "Boardwalk Camera Shop, 707 Boardwalk,
Atlantic City N.J. When re-ordering use No 689." I can't
imagine that the photo was reordered. We all look terrible.
The date, according to an inscription in my father's hand, is
June 12, 1949. He looks the worst of all. It is hard to believe
that the suit he is wearing could have been sold to him. "Ill-
fitting" doesn't begin to describe the wide floppy trousers drip-
ping out over his shoes and the wide-lapel jacket that looks
several sizes too big and yet tugs at the waist. My mother's
costume—a shapeless polka-dot dress that makes her look
fatter than she is, though she was never thin—is only slightly

less unfortunate. Marie, almost thirteen, wears a white blouse with puffed sleeves and a dark calf-length skirt that doesn't flatter her but isn't as bad as my mother's dress. Her face is beautiful, but set in an artificial smile. I am wearing a puffed-sleeve blouse like hers and an ankle-length skirt with a wide sash tied tight around the waist. I am slender, but the outfit looks mannered and unsuccessful, and my fifteen-year-old face isn't beautiful or appealing. A breeze has ruffled my short hair, as it has my mother's, but oddly has left Marie's neat central-parted hairdo untouched. My father is bald, as he had been since his late twenties. He looks like a vacuum-cleaner salesman.

I have photographs of my parents taken in Prague in the nineteen-twenties and thirties that contrast sharply with the

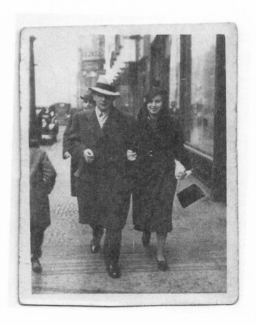

Atlantic City photo. My father looks dapper. He wears well-tailored suits that follow the lines of his well-proportioned body. My mother wears elegant, fashionable clothes. There is a photograph of her in a fox fur piece over an ankle-length coat, striding down Wenceslas Square on the arm of my father, who wears a fedora. There is an indoor picture of my father wearing eyeliner and lipstick and a wig and a woman's dress, posed with another man in drag and a third man in a tuxedo and bizarrely oversized round eyeglasses. I've assumed this picture was taken at one of the Dadaist balls thrown by a couple named Peta for the set of Prague sophisticates my parents belonged to.

When they emigrated to America, they put all that behind them. They became middle-class Americans. The Atlantic City photograph illustrates their embrace of the new life of less money and tamer pleasures. Atlantic City may have been stretching it. The place was not yet a gambling destination. It was a resort with fancy hotels and good beaches, where saltwater taffy was invented and the Miss America pageants were held. I have no memory of what we did in Atlantic City.

I don't know if we stayed in a hotel or just came for the day. I vaguely remember tourist junk being sold along the boardwalk.

Not every Prague émigré made the adjustment to the New World that my parents so gamely negotiated. I think of Ferdinand Peroutka, who had been a leading—perhaps *the* leading—political journalist in Czechoslovakia and never found a foothold here. I remember him as a bitter and sour old man, married to a younger, beautiful, and good-natured blond woman named Slávinka. I don't know how they lived. Perhaps she had a job and supported him? There was Mirko Tuma, a poet and thief. Friends like my parents took pity on him and gave him money. He was caught embezzling but somehow escaped going to prison. He was a sort of bad joke. On the other—my parents'—side of the émigré divide, there was Ivo Duchacek, another former big deal in little Československo, who became a sort of Edward R. Murrow figure on the Voice of America and then an outstanding professor of political science at City College. He and his delightful young second wife, Helena Kolda—she had emigrated with her parents and brother from Moravia—were close family friends, friends both of my parents and of Marie and me, because Helena—or, as we called her, Helenka—was so close in age to us. Helenka and her brother, Pavel, provided a link to middle-European between-the-wars absurdism. Before the Happenings of the sixties and seventies, we had our evenings of Tzara-ist posturing with Pavel and Ivo and Helenka. Helenka was the most uninhibited of us all. She would sing a song called "Kýčera"—from the Moravian mountain country, where shepherds would sing it from one peak to another—at

the top of her lungs, so that the furniture shook. We would do mad, inept dances. Ivo and my father exchanged erudite, witty, disgusting pornographic compositions. But this was a detour from the American life the Winns and the Duchaceks had fixed places in.

Many of the unassimilated émigrés—Peroutka among them—lived in Jackson Heights, Queens, in an apartment building that my uncle Paul, who had real-estate interests, found for them. I looked down on this bleak, grimy building and on Jackson Heights. I'm not sure whether I ever actually saw the building or just imagined it. The outer boroughs might have been Outer Mongolia. New York meant Manhattan. Jackson Heights was some sort of metaphor for failure and dreariness.

My mother called the building Centroklep, or Gossip Central. Everyone knew everyone else's business, and this got transmitted over the Queensboro Bridge to the Yorkville Czechs, who would respond with gossip of their own. Another of the Czech émigrés who lived in Centroklep was Karel Steinbach, a short, pudgy, very genial man who was by no means a failure. He was a gynecologist-obstetrician with a good job on Governors Island, in New York Harbor, which was then a military base; Steinbach gave gynecological examinations to the servicewomen on the island. As it happens, I owe my life to this man. The story is that in July of 1934 my mother had been in labor for three days and things were getting desperate. Steinbach, who happened to be passing by her hospital room, came in and pulled me out with forceps. Yet Steinbach remained—in my imagination at least—one

of the Jackson Heights deplorables. He had a mistress named Vlasta, who also lived in the building, a beautiful, kind woman, a divorcée, with a teenage son. I once had a ghastly arranged date with the son, whose name I don't remember, if I ever knew it.

There was a place in the country that brought together some of the Jackson Heights and Manhattan Czechs, a rural retreat called Lost Lake, in Putnam County, an hour and a half from the city. It came into being in 1927, when an ornery man named Harold Kline—ornery in the transparent way people could be at the time—bought a large piece of farmland and created an artificial lake on it, a sort of Walden Pond, along whose shores he built simple, rather beautiful cabins, to which a group of his White Russian friends flocked, filling the night air with the sound of balalaikas and mournful Russian song, or so the story went. By the time Lost Lake came into my family's life, the White Russians had gone to where White Russians go, and Harold Kline had to content himself with renting his cabins to a mix of Americans and Czech émigrés. My parents, the Traubs, the Duchaceks, and the Peroutkas were among the Czech renters. (Harold always made a point of spelling out his name as Kline, not Klein—and in other ways giving away the show of his idealism and bohemianism. But the cabins were brilliantly designed.)

My daughter, Anne, born in 1962, now enters the narrative with a recollection of the Peroutkas dating to the years when, as a small child, she stayed at the lake with her grandparents. It revolves around the Peroutkas' dog, a fluffy white thing called Fifinka, who had been trained to come running

when her master whistled a certain tune. Anne recalled for me how her grandparents would row across the lake to visit the Peroutkas, whistling the tune as they approached the dock, and how—to her delight—the dog would duly come bounding down the winding path to greet them.

After telling the story, Anne whistled the tune herself—amazingly, it has remained in her memory all these years—and I immediately recognized it as the theme of one of Antonín Dvořák's *Slavonic Dances*. The piece, an orchestral suite, is regularly played on WQXR, and I listen to it with mild boredom verging on irritation. But Anne's whistling of the theme flooded me with emotion. I can't exactly account for it—it seemed to act on me as it acted on the dog. It was as if the fifty-year-old ghosts of my parents, my child, and myself were calling to me from the shores of Lost Lake and I was helplessly responding.

I have remembered something else about the Peroutkas that Anne doesn't seem to have known. It's about the dog, another fluffy little thing, that succeeded Fifinka and the incredible fact that the Peroutkas named him Steinbach. I hadn't thought Peroutka capable of such mischievousness, and slightly revised my cold view of him. When the Peroutkas invited Steinbach out to the Lake, elaborate measures had to be taken never to call the dog by his wicked name.

God knows the truth but waits. I have just learned why we were in Atlantic City in June 1949. Marie, who undertook the editing of my father's archive when the family papers came to us after my mother's death, recently came across some stray items that she gave to Anne. I idly read a few entries from

one of my father's diaries, which was among them, and found this from 1949:

> 6/11 Driving to Atlantic City for American Neurological Assoc. convention with Joan, Janet and Marie. Thrill for the girls. Splendid weather and swimming in surf. They return by plane next day— Sunday 6/12 at 8:15 p.m. All of them fly the first time and enjoy it immensely. I stay till Wednesday, 6/15, back Wednesday night. Convention unexciting— to stay in Atlantic City more than 2 days is boring (understatement).

When I started this piece, I had had a murky, improbable memory of flying to Atlantic City. Now I know that there actually was a flight, but still I remember nothing about it. My father's diary goes on to mention a few more conferences he attended in Atlantic City, including one in 1950 that ended with the "thrilling experience of circling in an Eastern Airlines Constellation for 1 hour over New York because of fog and inability to land."

Bad Seats

A regular feature of my father's pocket diaries of the nineteen-fifties are his entries about the performances he attended at the old, wantonly destroyed Metropolitan Opera House on Thirty-Ninth Street, usually with one or another family member. He would cite the names of the operas and the singers and the conductors and give a terse, usually highly favorable opinion ("excellent," "beautiful," "outstanding"), though here and there he found something to criticize, such as the length of a *Figaro* ("interminable, from 8 to 11:45") or the girth of a singer ("ridiculously fat"). Every now and then he would set down a happenstance of the occasion, for example: "In the intermission [of Mascagni's *Cavalleria Rusticana* and Leoncavallo's *Pagliacci*] drinks with Janet in the Grand Tier

lobby (Scotch for me, Tom Collins for Janet). Last performance of our subscription."

Our seats were not in the Grand Tier—which was the third level of seats, above the orchestra and boxes—but on the fourth level, called the Dress Circle, above which rose two more tiers, the Balcony and the Family Circle. I once sat in the vertiginous top tier; the voices of the singers carried, though they were themselves barely visible, tiny doll-like figures ridiculously gesticulating. They came into better view on the Dress Circle level, but were still too far away to register as the characters they were representing. You could only make out their expressions with the aid of opera glasses. I don't recall that we resented our seats and wished for better ones, any more than we resented the riches of rich people and longed to be rich ourselves. The Dress Circle was what we could afford and where we belonged.

Here and there, in later years, I have had occasion to sit in orchestra and box seats, and to see throughout the opera what I had only briefly glimpsed when accompanying my father: the full play of emotion on the faces of the singers. I remember my own almost hysterical emotion while watching—from the vantage point of a perfect orchestra seat—Renée Fleming and Dmitri Hvorostovsky enact the scene of their tormented parting at the end of a Met performance of *Eugene Onegin*. Hearing them was only part of what the composer intended us to experience.

The inequality of audience experience is intrinsic to the performing arts and unique to them. Literature and painting and sculpture are mediums of equal opportunity. A rich reader's experience of *Anna Karenina* is no more intense than a poor

one's. The hedge-fund owner and the secretary see exactly the same *Raft of the Medusa*. But only the hedge-fund owner gets to see the expression on Azucena's face when she realizes she has thrown the wrong baby into the fire. With their *Live in HD* films of performances, the Met has attempted to give audiences a fairer shake with opera. Here we all have great seats, so to speak, but somehow it isn't the same as being at the opera house. Something is missing from those films. Or perhaps, more to the point, something has been added—the gigantic close-up—which blunts the magic that wafts out to even the lousiest seats in the opera house after the lights go down and the first bars of the overture sound.

I felt this magic at those performances in the nineteen-fifties. But I also felt the tedium of prolonged incomprehension. Supertitles had not yet been invented. Most of the time, what the characters were carrying on about was anyone's guess. In the interval between arriving at our seats and the start of the opera, we desperately read the plot synopsis in the program, but it didn't help much. Hearing great arias sung by great singers was elating (Jussi Björling, Eleanor Steber, Cesare Siepi, Helen Traubel, and Leonard Warren were among the names my father faithfully recorded); occasionally it was almost enough. But accompanying my father to the opera was not something Marie and I fought over, or that my mother was eager to do. Sometimes, I gather from the diaries, my father had to ask a distant relative or a friend of the family to fill the second seat of the relentless subscription.

In his entry on the *Cavalleria* and *Pagliacci* evening with its Tom Collins and scotch on the Grand Tier, he also noted that a performance of the pair at the Národní Divadlo, or

National Theater, in Prague in 1911 was his first experience
of opera. He was ten years old. This has summoned the mem-
ory of my own first opera: Bizet's *Carmen*, to which my father
took me at an early age—perhaps also ten—performed not at
the Met but by a lesser opera company at a small theater in
Manhattan. The memory is indistinct—I hear or see none of
the performance—but it must have made a deep impression,
for *Carmen* has remained my favorite opera. I practically know
it by heart. In my mind I hear the tinny sound of the chil-
dren's chorus with which the opera opens and the hush that
falls over the audience with a thud during Micaëla and Don
José's first-act love duet and the menace of the music of the
prelude to Act III, set in the smugglers' camp to which Car-
men has lured the pathetic Don José. I go to *Carmen* when-
ever I can. I have seen a Swedish version in which Carmen
sang the "Habanera" lying on the ground on her back; I have
seen a film version set in South Africa in which Don José was
an MP who drove a jeep; I remember *Carmen Jones*, a black
version set during the Second World War—there isn't a ver-
sion that hasn't pleased me. *Faust*, by Bizet's mentor Gounod,
is another of the operas that delight me no matter where I
sit. The two of them share a quality of Frenchness to which
both my parents, as cultivated Czechs living in Prague in
the twenties and thirties, were alive. French was their third
language (German was the second), they were well versed
in French literature, and France was a frequent vacation
destination.

I possess a photograph, identified on the back as a picture
of my father at Chateaubriand's grave, that always mystified
and vaguely disturbed me. What kind of graveside memento

is a photograph of a man in a bathing suit—one of those nineteen-twenties chest-covering ones—leaning against a spiked iron railing that makes a tight square around a bulbous cross mounted on a stone platform that sits in sand at the edge of the sea? My father is smiling and wears a white bathing cap. The whole thing has the air of a Dada performance that didn't quite come off. Only now, thanks to Google, do I know that this weird grave site (accessible only when the tide is out) actually exists—on the island of Grand Bé, near Saint-Malo—and that Chateaubriand himself made the arrangements for his singular seaside burial.

Another example of the strength of my parents' French connection is their choice of Juan-les-Pins, on the Riviera, for their honeymoon, in 1933. There was a story I heard throughout my childhood that the honeymoon was spoiled when my father spilled gravy on his tie. Children believe what they are told. It took me many years to realize that the story (meant to illustrate my father's obsessiveness) was probably not literally true. I visited Juan-les-Pins myself many years later with my second husband, during a vacation in the South of France. We did not find it especially beautiful or interesting. But we did not visit the sandy beach—as opposed to the typical black stone Riviera beach—that was a main feature of the town, and may have been what especially drew tourists from coastline-less Bohemia.

But it was my first visit to France, in 1960, with my first husband, that produced my own chronic case of Francophilia. I don't know what kind of impervious boor you have to be not to notice that everything in France looks better than things look anywhere else. There is some sort of atavistic

aestheticism embedded in the French soul. The smallest ob-
jects of daily use are touched with beauty. The music of Bizet
and Gounod partakes of this tropism toward the elegant and
comely. "Salut, demeure chaste et pure," the famous tenor
aria in the garden scene in *Faust*, with its culminating un-
earthly high C, is an especially commanding example of the
deliciousness that my father sought—and found—in the old
opera house of his new country.

Mary Worth

When I was in grade school, I furtively read the comic strips in the afternoon newspaper my father brought home after work. I say "furtively" not because I had been forbidden to read comics but because I knew that my parents disapproved of them. Actually, I knew no such thing. I have no memory of them ever discussing comics with Marie and me. It probably never entered their minds to do so. But somehow the idea had lodged itself in my mind that reading comics was transgressive, and that I must never get caught doing it.

Books were what one was supposed to read. Books were good great things. My father always gave each of us a book for birthdays and Christmas. I still have some of these gift volumes, with inscriptions by him: *David Copperfield*, for example, given to me on my tenth birthday, and Turgenev's *Sportsman's Sketches* when I was twelve. The idea was to introduce us to classic literature, and it was a good idea up to a point. But (for me, anyway) there was a downside. To negotiate these books that I wasn't old enough to read properly, I learned how to read them as best I could: by skipping what I thought of as the boring passages (usually the descriptive passages) and moving on to the interesting passages of dialogue or plot narration that beckoned ahead. These terrible reading habits stayed with me long after I needed their crutch-like

help. Skipping had become ingrained, and it took some time for the realization to sink in that, like the lady who walked in the field with gloves, I was missing so much and so much, and had better take myself in hand.

I should not give the idea that my parents were literary snobs who read only Great Works and looked down on humbler forms of writing. They were not George Steiner. They belonged to the Book-of-the-Month Club, which would send them monthly "dividends," such as (I remember seeing these volumes for years in the living-room bookcase) *Victory Through Air Power* and *Death Be Not Proud*. The subject of the first speaks for itself; the second, by John Gunther, was about the death of his son from a brain tumor. I read the Gunther book; I'm not sure I read *Victory Through Air Power*. It's possible that it wasn't even a Book-of-the-Month Club selection. But the title is a reminder that those years of formative reading took place in the shadow of the Second World War— whose chill, however, I have no memory of feeling. I felt safe and secure in wartime New York. I held fast to my child's hedonistic prerogatives. I remember a moment of acute consciousness of the special delightfulness of a game called potsy, a form of hopscotch, played on the sidewalk, on a playing field of chalked lines making squares. Sitting on a stoop, eagerly awaiting my turn, I experienced a feeling that was like the recognition of the face of joy.

The newsreels that were shown in movie houses throughout the war—of advancing tanks and spiraling fighter planes and buildings that had been bombed and ships that had been blown up—were more annoying than frightening for us kids. We waited for them to be over and for the feature film or the

cartoon to begin. We talked about the Japs more than about the Germans. The term "Holocaust" had not yet entered the language; the camps had not yet been liberated by disbelieving Allied soldiers. But we were a Jewish refugee family. Didn't I know something about why we had come and what we had escaped?

There was a panel at the beginning of one of the comic strips in the afternoon newspaper—the one called *Mary Worth*—that showed a tree and two paths. The caption spoke in ominous lettering about someone who was lost and in danger. Before I could finish reading, my father walked into the room and I thrust the newspaper aside so I wouldn't be caught looking at a comic strip. Later, I tried to find the paper to finish reading the strip, but couldn't. The dread that permeated the image of the tree and the paths remained with me for a long time.

The Apartment

A piece of Italian china has appeared in my mind's eye. It is a plate decorated with a sort of faux folk-art flower design, red and green and pink sprigs on a white background. There was a fashion for this type of tableware in the sixties and seventies among upper-class women in New York. It was pretty and it wasn't cheap.

Nor was it my taste. I preferred plain Bauhaus-style things sold in stores like Design Research (a mecca of modernist design, the creation of an advanced modernist architect) and Bonniers (a Swedish store on Madison Avenue of serene

Scandinavian-modern beauty). But when it came to buying plates for my illicit lunches with G. in a one-room unfurnished apartment in the West Fifties, I chose the Italian china, sold in department stores like Bloomingdale's and Lord & Taylor. Adultery takes one out of one's usual life, sometimes in unusual ways. Our midday trysts had started in the Belvedere Hotel, in the West Forties, near the offices where we worked. But the hotel, never grand, had grown increasingly seedy, and one day we arrived to find that it had become a welfare hotel, as they were then called. So G. rented the apartment in the West Fifties for our weekly (sometimes biweekly) engagements with guilty love.

We also bought a bed and a table and a tablecloth and two chairs and forks and knives and wineglasses. One day when we came to the apartment, the Italian plates were gone. Someone had come in through the window that looked out on an alley and taken them. Over the next weeks, the wineglasses and cutlery and tablecloth disappeared, then the table and chairs. The bed remained for a while, but finally it too was gone. This was the time of drug crimes in the city. The apartment was in a bad neighborhood; we stopped going to it, though G. had to continue paying the rent until the lease ran out.

Years later, G. (now my husband) told me of a brief encounter in Paris, a few years after the war, when he was there alone. His wife had stayed in New York, perhaps to be with their small children. One late morning, he was sitting in a park and struck up a conversation with an attractive woman who was sitting nearby with a small child. As noon approached, she invited him to her apartment, a block away. At the apartment—there were signs of a husband who was

at work—she gave the child his lunch, tucked him in for his nap, produced an elegant lunch for G. and herself, and went to bed with him. He told the story as if remembering a pleasant dream. I did not feel jealous of the woman. You do not feel jealous of people in dreams.

In Freudian dream interpretation, the dreamer associates to details of the dream in order to penetrate its disguises and discover what surprising thing it is "about." The analyst keeps asking about this detail of the dream and that one. "What comes to mind?" he asks. "What does this bring to mind?" "Nothing," the dreamer will say, "nothing comes to mind." He may then blurt out some trivial image or idea or recollection (I went to the cleaners yesterday) that is entirely unrelated to the dream—and, of course, turns out to be the key to its meaning. I am struck by the humility of Freudian dream interpretation, of the analyst's refusal to put his ideas about the patient's inner reality ahead of the patient's superior (if as yet unknown to him) knowledge. His interpretation is a mere summation of the *patient's* findings. G. died in 2004, and I cannot prod him for associations to his "dream" of the woman in the park. I can only offer some associations of my own derived from other of his stories, on the chance that some truth will leak out of them about G.'s imaginative life as well as about mine.

One of these stories is the story of G.'s war. He landed in Normandy on D-Day and fought in France and Germany as a lieutenant in an infantry division. Thirty years later, a loud clap of thunder would still make him startle and cower; it was his madeleine of enemy artillery fire. There was a box of medals somewhere in the house. He almost never talked about

his army experiences. He eventually wrote about them in a memoir called A *Life of Privilege, Mostly*, though there was one experience that went unrecorded. He had told me—we were sitting around one evening after dinner when he suddenly started to talk—that his platoon liberated one of the Nazi camps. He cried as he described what he saw, and I cried with him.

Was G.'s story of the encounter in the park—whose every detail spoke of life's capacity for ease and pleasure and delight—a homeopathic counter-narrative to the story of the war? G.'s memoir touches with characteristic reticence on his own experiences. Of the disastrous (for the Allies) Battle of Hürtgen Forest, in the late fall of 1944, he notes that "it was the worst fighting in the whole war," but he does not dwell on the hunger, cold, filth, and ever-present, realistic fear of being killed that he and his fellow soldiers endured for two months. He told me a little about those months. He could not bring himself to write about the obscenity of the camp.

There is another, lighter story, the story of G.'s prewar romance with France and the French. I wrote earlier about my parents' Francophilia. When G. was a child, he and his mother and stepfather and younger brothers would sail for France in June and stay there for the summer. G. learned to speak French the first summer, being of the age (eight) when this feat is best negotiated. He never lost his knowledge of the language, and it was a pride and pleasure of his life that he could speak it the way Frenchmen do. He acquired the intonations and cadences and even the facial expressions of a native speaker. He would become another person when he spoke French. When he and I traveled in France, I never

uttered a word of my high-school French. When I say he became another person, I think I mean that he impersonated someone who was not the American he was. When he met the woman in the park, he was that other person. His real-life persona was not so far removed from the assumed one; but as an imaginary Frenchman he could move across the border of conventional morality with an ease and economy not available to an heir of American puritanical traditions. Our trysts in the apartment in the West Fifties were the turgid American cheating-on-your-spouse-and-feeling-awful-about-it kind of thing. It was messy. It was the opposite of the elegant, unencumbered encounter in Paris, between two free or freer spirits.

What about the Italian plate I described at the beginning of this piece? What did it mean to me? Why did it come to mind after so many years? I know the answer, but—like a balky child—I find myself reluctant to give it. I would rather flunk a writing test than expose the pathetic secrets of my heart. The prerogative of cowardly withholding is precious to the most apparently self-revealing of writers. I apologetically exercise it here.

On Being Sick

When I was sick as a child, terrifying images would come to me at night of planetary globes turning round and round and moving ever closer to appalling, inexorable disaster. Yeats, in the opening lines of "The Second Coming," writes of a similar dread: "Turning and turning in the widening gyre / The falcon cannot hear the falconer; / Things fall apart; the centre cannot hold." Were my oneiric imaginings of awful round things spinning toward world-ending catastrophe messages from Jung's "collective unconscious," powerful flashes of his reductionist truths? My memory of those images—whatever their ontological status—has stayed with me all my life, though, mercifully, they themselves never reappeared.

Other memories of childhood illness are less dire. I have no memory of the illnesses themselves; they were the standard infectious diseases, such as measles, for which vaccines had not yet been invented, and I was never seriously ill. What I most remember was the pleasant cosseting Marie and I received from my mother: that roast squab and profiteroles, hardly the bland gruel and trembling junkets that are all the sick person is supposed wanly to be able to get down. These are still among the dishes I consider the most luxuriously delicious of all foods. We must have been in the recovery stage of our illnesses when my mother went to the effort of making

them. She roasted the little birds to a nice degree of doneness. For the profiteroles she made the puff pastry from scratch— there were no ready-made doughs then—melted the chocolate, whipped the heavy cream.

She cooked from the book of handwritten recipes (now in my possession) that she had brought here from Czechoslovakia. I had been struggling to remember the Czech name for profiteroles, but it kept eluding me. Then it leaped off the page of the cookbook: *indiánky*, little Indians. The Czech language diminutizes everything it can lay its hands on. The Czech name for the fancy French confection adds a dimension of homeyness to it, evoking with special poignancy the lovingness and tenderness of my mother's care.

Sam Chwat

Once a week in the spring of 1994, I would bicycle over to a brownstone on West Sixteenth Street to see a man named Sam Chwat in his ground-floor office. He called himself a speech coach, and a large part of his business was to train actors who had been cast as Prospero, say, or Creon, so that they did not sound as if they came from the Bronx or Akron, Ohio. But I was not an actor seeking help with a role. I was seeing Sam for something else, something a bit apart from the other speech-related services he offered. A friend who had sought

him out for help with public speaking had recommended him to a lawyer who was representing me in a lawsuit. Ten years earlier I had published a two-part article in *The New Yorker* about a disturbance in an obscure corner of the psychoanalytic world whose chief subject, a man named Jeffrey Moussaieff Masson, hadn't liked his portrayal and claimed that I had libeled him by inventing the quotations on which it was largely based. So he sued me and the magazine and the Knopf publishing company, which had brought out the article as a book called *In the Freud Archives*.

In an afterword to a subsequent book, *The Journalist and the Murderer* (1990), I wrote about the lawsuit, taking a very high tone. I put myself above the fray; I looked at things from a glacial distance. My aim wasn't to persuade anyone of my innocence. It was to show off what a good writer I was. Reading the piece now, I am full of admiration for its irony and detachment—and appalled by the stupidity of the approach. Of course I should have tried to prove my innocence. But I was part of the culture of *The New Yorker* of the old days—the days of William Shawn's editorship—when the world outside the wonderful academy we happy few inhabited was only there for us to delight and instruct, never to stoop to persuade or influence in our favor. As the Masson case wound its way through the courts—dismissed at first, then reinstated, and eventually brought to trial—the press-watching public became increasingly pleased by the spectacle of the arrogant magazine brought low by the behavior of one of its staff writers. While Masson gave more than two hundred accusatory interviews, I—in dogged accord with the magazine's stance of unrelenting hauteur—said nothing in my defense. Nothing at

all. Nothing of course produces nothing, except further con-firmation of guilt.

But it was at trial that the influence of *The New Yorker* proved to be most dire. There was a style of self-presentation cultivated at the magazine that most if not all staff writers had adopted and found congenial. The idea was to be reti-cent in real life: self-deprecating, and maybe here and there funny, but always keeping a low profile, in contrast to the rather high one of the persona in which we wrote. I remember my shock at meeting A. J. Liebling for the first time. I had been reading him for years and imagined him as the suave, handsome, brilliantly articulate man of the world that the "I" of the pieces portrayed. The short, fat, boorishly silent man I met was his opposite. I came to know Liebling and to love him. But it took a while to penetrate the disguise of both innate and magazine-induced unpretentiousness in which he made his way through the world as he wrote his wonderful pieces narrated by an impossibly cool narrator.

When I took the stand at the trial in San Francisco in 1993, I could not have done worse than to present myself in the accustomed *New Yorker* manner. Reticence, self-deprecation, and wit are the last things a jury wants to see in a witness. Charles Morgan, Masson's clever and experienced lawyer, could hardly believe his good fortune. He made mincemeat of me. I fell into every one of his traps. I came across as arrogant, truculent, and incompetent. I was at once above it all and utterly crushed by it. My lawyer, Gary Bostwick, succeeded in inflicting some damage on Masson—he portrayed him as boastful and sex-crazed—but it was not enough to offset the damage I had helped Morgan inflict on me. The jury agreed

with the plaintiff's accusation that five quotations in my article were false and libelous. A jubilant Masson had only to wait for the jury's final determination of how many millions of dollars in damages he would collect from me. (*The New Yorker* itself was cleared of the charge of "reckless disregard" required for a finding of libel; Knopf had extricated itself from the case years earlier.)

Then the gods played one of their little reversal-of-fortune pranks. The jurors came back from their deliberations with the news that they were deadlocked. They could not agree on the amount of damages. Some thought Masson should be awarded millions of dollars. Others thought he should collect nothing. One juror thought he should collect one dollar. The judge could not move them and was obliged to declare a mistrial and to schedule a new trial. I had suffered an ignominious defeat, but I had been given a second chance to prove my innocence. *Whew!*

Not many of us get second chances. When we blow it, our fantasies of how we could have done it right remain fantasies. But the fantasy had become a reality for me, and I was determined not to waste the incredible good fortune that had come my way. My visits to Sam Chwat were part of the half-year of preparation for the second trial, almost like a military campaign, to which Bostwick and I devoted ourselves. Sam was the Professor Higgins who would transform me from the defensive loser I had been in the first trial to the serene winner I would be (and was) in the second one.

The transformation had two parts. The first was the erasure of the *New Yorker* image of the writer as a person who does not go around showing off how great and special he or

she is. No! A trial jury is like an audience at a play that wants to be entertained. Witnesses, like stage actors, have to play to that audience if their performances are to be convincing. At the first trial I had been scarcely aware of the jury. When Morgan questioned me, I responded to him alone. Sam Chwat immediately corrected my misconception of whom to address: the jury, only the jury. As Morgan had been using me to communicate to the jury, I would need to learn how to use him to do the same.

There were some minor but not unimportant particulars that Sam inserted into this new concept of myself as a guileful performer. I would need to dress differently. At the first trial I wore what I normally did when out of my work uniform of blue jeans, namely skirts or trousers with jackets in black or subdued colors, clothes that looked nice but didn't draw attention to themselves. The idea was to be tasteful. Another "No!" The idea was to give the jurors the feeling that I wanted to please them, the way you want to please your hosts at a dinner party by dressing up. This would be achieved by a "menu," as Sam called it, of pastel-colored dresses and suits, silk stockings and high heels, and an array of pretty scarves. The jurors would feel respected as well as aesthetically refreshed, the way they do by women commentators on TV who wear colorful clothes of endless variety. I did as Sam advised, and after the announcement of the verdict, when Bostwick and I went to speak with the jurors, they made a point of commenting on my clothes. They said that each day they looked forward to seeing what I would wear next, especially which scarf I would choose.

There was a seemingly small but all-important technical

problem that, for a while, neither Sam nor I could solve. The witness stand was located midway between the interrogating attorney's lectern on my right and the jury stand on my left. How was I supposed to perform for the jurors when I had to turn my back on them while being questioned? The answer came to me one day in a flash. I would position my chair so that it partially faced the jury. Thus, when Morgan questioned me, I could reply over my shoulder, while remaining frontally connected to the jurors.

The second and most crucial part of the second-chance work was to make me faster on my feet under cross-examination, in fulfillment of the fantasy of saying what I should have said in the first trial instead of what I did say. Bostwick assumed that Morgan would repeat the questions that had served him so well, and he and I devised answers to them that brought *l'esprit de l'escalier* to a new level. At trial, Morgan did not disappoint us. He confidently asked the old questions and didn't know what hit him when I produced my nimble new formulations. I remember one of the most satisfying moments. At the first trial Morgan had repeatedly tortured and humiliated me with the question "He didn't say that at Chez Panisse, did he?" I had wiggled and squirmed. Now I could answer him with crushing confidence.

I need to give the reader some history here. In the early months of the (ten-year-long) lawsuit, Masson claimed that he had said almost none of the things he was quoted as saying in the article. When a transcript of my tape-recorded interviews was made, it showed that he had said just about all the things he denied saying. But five quotations remained that were not on tape:

1. "Maresfield Gardens would have been a center of scholarship, but it would also have been a place of sex, women, fun."

2. "I was like an intellectual gigolo—you get your pleasure from him, but you don't take him out in public."

3. "[Analysts] will want me back, they will say that Masson is a great scholar, a major analyst—after Freud, he's the greatest analyst who ever lived."

4. "I don't know why I put it in."

5. "Well, he had the wrong man."

I had lost the handwritten notes that would have been enough to prove the genuineness of the first three—the most incendiary—quotations; I had only typewritten versions, which did not meet the standard of proof. Thus, under our anxiously accommodating legal system, Masson had the right to a trial by jury. As it turned out, two years after the second trial, the lost notes were found at my country house, in a notebook that my two-year-old granddaughter pulled out of a bookcase, attracted by its bright red color. It had all been for nothing.

Meanwhile, however, as Masson's day in court approached, he and Morgan had a problem to solve: how to fill the time of the trial. The five quotations—fatuous as they might have made Masson appear—were surely not compelling enough to justify making eight men and women sit on hard chairs for four weeks and decide whether or not to award him millions

of dollars. A portrait of me as a malevolent woman out to destroy the reputation of a naively trusting man needed to be fleshed out by other crimes than the one of five lines of misquotation. They hit on the crime of "compression" as a leading one.

Their opportunity arose from an incident in 1984, when an article appeared on the front page of *The Wall Street Journal* written by a young woman named Joanne Lipman, who had been hired as a staff writer by the *Journal* upon her graduation from Yale, in 1983. The article was about the liberties that the writer Alastair Reid took in reportage from abroad he had been publishing in *The New Yorker* since 1951. Reid, born in Scotland, was primarily a poet and translator, notably of Jorge Luis Borges, and also known for having seriously irked Robert Graves by stealing one of his White Goddess girlfriends. Lipman first encountered Reid in her student days at Yale, where she heard him speak at an extracurricular seminar and was struck by the unconventional way he said he practiced journalism. After starting at the *Journal*, she interviewed Reid, who unrepentantly elaborated on these practices, which the newspaper considered horrible enough to put on its front page as evidence of the fraud *The New Yorker* had been perpetrating on readers of its "prestigious pages."

Reid happily babbled to Lipman about the things he had made up in his reports from Spain. He had set a scene in a bar that had closed years earlier. He had invented conversations. On another occasion, he revealed that he had pieced together several people into a composite character. As an unacknowledged legislator, he felt bound to go beyond what the non-poet journalists among us do. Lipman wrote, "'The

implication that fact is precious isn't important,' Mr. Reid says. 'Some people (at *The New Yorker*) write very factually. I don't write that way. . . . Facts are only a part of reality.'" Lipman also interviewed Shawn, who tried to say that of course *The New Yorker* is as factual as it is possible to be while not saying that Reid ought to be drawn and quartered.

Lipman's story created a scandal in the journalistic world, one that was deeply enjoyable for those who did not work at *The New Yorker* and mortifying for those who did. I remember feeling mad at Reid for opening his big mouth and talking about what we do in our workrooms. I assumed that he strayed further from factuality than the rest of us ever imagined or were even capable of doing, but I also knew that some *New Yorker* writers—the great Joseph Mitchell, for example—quietly used techniques that resembled some of those that Reid preened himself on using. Mitchell had suffered some embarrassment when a character he called Mr. Flood was outed as a composite.

The Alastair Reid affair fell neatly into Morgan's hands as a solution to the problem of how to fill the time at his disposal to make me look bad. Although I hardly shared Reid's contempt for factuality, I had unapologetically, almost unthinkingly, used a literary device in *In the Freud Archives* that was commonplace at *The New Yorker* but that outside journalists— in the accusatory atmosphere following the Lipman article— saw as another violation of the reader's good faith. The device was the uninterrupted monologue in which subjects made preposterously long speeches in impossibly good English. Anyone could see that the speech had never taken place as such but was a compilation of what the character had said to

the reporter over a period of time. Not everyone liked the convention, but no one thought it was deceptive, since its artificiality was so blatant.

I set my long monologue with Masson at the restaurant Chez Panisse, in Berkeley, where he and I ate lunch on the first day of my interviews with him. During the lunch he spoke excitedly of the events that had catapulted him from an impressive and well-paid position as director of the Freud Archives to his present condition of jobless humiliation and indignation. He spoke wildly and not always coherently. Over the next six months I spoke with him dozens of times on the phone and a few times in person, allowing him to fill in the gaps of his account—and to come up with ever more imaginative formulations expressing his sense of having been wronged. I then wrote my monologue. It never occurred to me that I could be doing anything wrong by using scraps that had been acquired at different times.

But Morgan's "He didn't say that at Chez Panisse, did he?" question, with its implication that the reader was being deceived, was hard to answer. During our period of preparation for the second trial, Bostwick, Chwat, and I spent a great deal of time on it. Finally, an answer evolved from our efforts that I still recall the pleasure of delivering on the stand. It took the form of a long speech about the monologue technique that Morgan kept interrupting but was unable to stop. I went relentlessly on and on. I talked about the difference between the full and compelling account of his rise and fall in the Freud Archives that Masson gives in the article and his wandering, incomplete speech in the restaurant. I spoke of the

months of interviews out of which, bit by bit, the monologue was formed. I concluded by saying, "I have taken this round-about way of answering your question, Mr. Morgan, because I wanted the jury to know how I work, and what we're talking about here in talking about this monologue." "Mrs. Malcolm, you will be given all the chances in the world to tell this jury how you work, so don't worry about it" was Morgan's lame riposte. I didn't worry. I had already gleefully seized my oppor-tunity. When Bostwick and I interviewed the jurors after the verdict and asked them what they thought of the monologue technique, they said they saw nothing wrong with it. They said they understood that writers had artistic obligations.

At the second trial Bostwick improved his own perfor-mance as Masson's antagonist. In his best moments, he played him like a matador playing a bull. Under Bostwick's punish-ing interrogation, Masson seemed pathetic, as he never was in my article. I almost felt sorry for him.

Sam Chwat died of lymphoma in 2011 at the age of fifty-seven. I was shocked and saddened by the news. I remember my sessions with him with undiminished gratitude and plea-sure. He was a straightforward, modest, kind person, with a fine, interesting mind. His unspoken but evident distaste for the *New Yorker* posture of indifference to what others think and his gentle correction of my self-presentation at trial from unprepossessing sullenness to appealing persuasiveness took me to unexpected places of self-knowledge and knowledge of life. After the trial, I had no further occasion to appear in public and did not seek any. I relapsed into my usual habits of solitary work and private intimacy. Looking back on my

life as a writer, I don't regret the trade-off of the openly performative for the less obvious way writers draw attention to themselves. My memories of the time in my life when I went onstage and performed like a trouper seem somewhat unreal now. But my rehearsals with the man who had briefly made me into one remain indelibly vivid.

Holbein

A few more things about the red notebook: after my grand-daughter found the lost red notebook, I went to the place in the bookcase where it had sat all those years, to see if there were any other mementos of the time in which I had scrib-bled "sex, women, fun" and "I was like an intellectual gigolo" and "after Freud, he's the greatest analyst who ever lived" into it. One item emerged: a pamphlet of an exhibition of Holbein portraits at the Morgan Library to which I had taken Masson and his girlfriend when they were visiting New York a few months after I started interviewing him in California. I had continued to interview him in New York, and it was during a session at my house that he uttered the words that were to become the heavy-duty fulcrum of his lawsuit. I took notes because I had dropped and broken my tape recorder.

At the first trial, when Morgan tried to discredit my ac-count of the interview and of the visit itself, I offered the Holbein exhibition as a corroborating event. Then some-thing wonderful happened. Morgan fixed me with his Mr. Tulkinghorn gaze and said, "Holbein is a photographer, isn't he, Mrs. Malcolm?" All my despair about the trial, the feeling that our side was losing and that I was being outwitted at every turn, fell away as I took in Morgan's delicious blunder.

Afterward, friends who had attended the trial joined me in chortling over "Holbein, the photographer."

But actually nothing wonderful had happened. When I corrected Morgan, no wave of contempt swept over the jury stand. The jury couldn't have cared less what Holbein did for a living. Only my snobbery had been activated.

In the previous chapter, I wrote of the opportunity that had come my way to master the art of pleasing rather than alienating a jury, and of the happy result of that education. But as the trial receded from memory, I relapsed into some of my old habits of mind, the habits that had made Morgan's ignorance of art history seem so delightfully funny. The picture in my mind's eye of the pamphlet of the Holbein exhibition evokes this incident and its aftermath—but only the picture. The pamphlet itself is lost.

A Work of Art

For many years my late husband, Gardner Botsford, kept a
small black-and-white snapshot on his desk of a man and
woman wearing shorts, walking one behind the other on a
tennis court. I didn't know who the couple were but assumed
they were friends from Gardner's life before our marriage,
people he had been close to and fond of. One day I asked him
who they were and he laughed and said he had no idea. He
had plucked the picture from a pile of rejects on their way to
the wastebasket. It had leaped out at him as an example of
an outstandingly terrible snapshot, one that had everything
the matter with it. The couple had their backs to the cam-
era; the tennis court showed a few white lines; there were

undifferentiated shrubs and trees edging one side of the as-
phalt. That was all. I saw what my husband saw and laughed
with him. There was no reason for the existence of this pic-
ture. Keeping it was a wonderful exercise in absurdism.

A few years later, in 1980, I had occasion to think of this
picture in a new way. I was selecting illustrations for the title
essay of *Diana & Nikon*, a collection of my pieces on photog-
raphy, which had run unillustrated in *The New Yorker*. One
of the key moments in the essay was a discussion of a new
kind of avant-garde photography that took its inspiration—
and to all intents and purposes was indistinguishable from—
the home snapshot. Robert Frank, Garry Winogrand, Emmet
Gowin, Lee Friedlander, Joel Meyerowitz, and Nancy Rex-
roth were among the practitioners of this school of deliber-
ately artless photography that had recently been celebrated
in a book called *The Snapshot*, published by Aperture. In
his introduction, the editor, Jonathan Green, felt impelled
to inform the reader that the photographers represented in
the book were "not snapshooters but sophisticated photog-
raphers." The most sophisticated among them, perhaps, was
Rexroth, who used a $1.50 toy camera called the Diana (thus
my title) that also came in a model that squirted water when
you pressed the shutter.

In the essay "Diana and Nikon," I reproduced four pic-
tures from *The Snapshot* to illustrate the new aesthetic. Except
that one of the pictures was not actually from the book but
from Gardner's desk: the snapshot of the couple on the tennis
court. The temptation was too great. The gates stood open
too wide. When the book appeared, there, on pages 70–71,
illustrating the work of *The Snapshot*'s "sophisticated photog-

raphers," was a spread of four pictures with captions under them crediting Joel Meyerowitz, *Untitled*; Robert Frank, *Untitled*; Nancy Rexroth, *Streaming Window, Washington D.C.*, 1972; and G. Botsford, *Untitled*, 1971.

The reader may be wondering how this act of mischief could have gone undetected. Didn't anyone at David Godine, the book's publisher, notice? Or was the estimable and amiable Godine in on the mischief? As an A. J. Liebling character once said, "Memory grows furtive." I no longer remember how it was done or whether Godine knew. But I do remember that when *Diana & Nikon* was published, no one connected with *The Snapshot* ever wrote an indignant letter, or even a puzzled one. No one noticed at all. Then something occurred that gave me more pleasure than perhaps anything has before or since. A reviewer of my book, one who did not like it and was particularly irked by the "Diana and Nikon" essay, singled out the Botsford picture as a demonstration of my wrongheadedness, my pathetic inability to differentiate a work of art from an artless snapshot. I wish I had kept the review and could quote from it. But its delicious condescension is indelibly etched in my memory.

As if this wasn't enough wicked joy for a single lifetime, four years later the Botsford picture was reproduced once again, this time in a historical and critical study of snapshots called *Say "Cheese"!*, by a collector and critic named Graham King. In the chapter called "Snapshot Chic: How Contemporary Photography Snapped Up the Snapshot," King covers some of the boggy ground I had covered in *Diana and Nikon*, and to illustrate the problem of telling real and fake snapshots apart, he offers a quiz in which eight images—among

them the Botsford photo—are shown without identification. "Snapshot or imitation?" King writes.

> These eight photographs are either anonymous snap-shots or professional examples of "Snapshot Chic" photography. Can you guess which is which?...The answers are given on p. 212.

On page 212 we learn that only three of the images are anonymous snapshots. The others—by William Eggleston (two), Joel Meyerowitz, Tod Papageorge, and Gardner Botsford—are "professional studies which are in important collections or which have been published." I had built better than I knew. I look forward to the day when the picture of the couple on the tennis court will assume its place in an important collection, and I will take up mine in the annals of horsing around.

Afterword

BY ANNE MALCOLM

Like most of us, my mother appears in a lifetime of photographs, some of which are reproduced in these pages. She also wrote extensively about photography: her first book, *Diana & Nikon*, written before she alighted on the subjects—psychoanalysis, journalism, biography, and the law—for which she was best known, was a collection of essays on photography she wrote in the 1970s when she was the photography critic for *The New Yorker*.

She was also herself a photographer. Long before I was born, she had acquired a lovely leather-bound Leica, set up a darkroom in the closet, and was taking striking black-and-white photographs of friends and family. The darkroom fell by the wayside once she had a baby to look after, but she went on taking pictures and having them professionally developed: there are drawers and drawers of contact sheets in her apartment, from which the artful photographs that hung throughout her home were drawn. In one dog-eared envelope from the mid-1950s (she would have been just out of college), I found a typewritten price list for her services as a professional portrait photographer: tantalizing glimpse of a road not taken. It was only in the last fifteen years of her life that she actually made the move from amateur to professional, with a series of large-scale studies—portraits, really—of burdock leaves, which were shown at Lori Bookstein Fine Art in New York and subsequently published under the eponymous title *Burdock*.

The book in your hands was supposed to have one last chapter, which my mother's final illness did not allow her to write. I don't know much about what she had in mind, only that she wanted to write something about her own lifelong interest in taking pictures. It would have made a wonderful subject for her, and a perfect ending to this book. It is fruitless to try to imagine what she might have written: the unlooked-for and idiosyncratic was her stock-in-trade. I'm led instead to the place where she did write a little about herself as a photographer: the brief, brilliant introduction she wrote for *Burdock*.

"Richard Avedon's portraits of famous people," she wrote,

> have been a model for my portraits of uncelebrated
> leaves. . . . The ravages of time and circumstances on
> the faces he photographed were mercilessly, some-
> times gruesomely recorded. As Avedon sought out
> faces on which life had left its mark, so I prefer older,
> flawed leaves to young, unblemished specimens—
> leaves to which something happened. . . .
>
> Photography is naively believed to reproduce vi-
> sual actuality, but in fact the images our eyes take in
> and the images the camera delivers are not the same.
> Taking a picture is a transformative act.

That writing is a comparably transformative act is of course a central preoccupation, perhaps *the* central preoccupation, of her work. The reportorial eye—and I—are never far from her mind. Even as she tells us a story, she reminds us of her own presence, as the lens through which that naively imagined "actuality" is being filtered. Did she see some continuity between her youthful experiments behind the camera's viewfinder and the writer's craft on which she settled instead?

In a review of an exhibition of my mother's collages, Maureen Mullarkey shrewdly observed that "a writer's eye for telling details is quickened by the same nerve that excites pictorial intelligence. . . . Malcolm's journalism career began with articles on interior decoration, design and photography. The visual preceded—and, throughout her working life, informed—everything." My mother herself liked to characterize her early career at *The New Yorker*, where she wrote

shopping columns with titles like "Gifts for the House," as a wonderful apprenticeship in learning to describe things. In the days before color photography became cheap and ubiquitous, the pen was obliged to do the camera's work, and the knack she acquired then for transforming "the images her eyes took in" into something that sprang to life in the reader's mind's-eye never left her.

So it seems entirely fitting, even foreseeable in hindsight (another instance of her gift for making the unexpected retrospectively obvious), that when my mother turned her hand to a kind of memoir, it should be built around a series of images. She was famously wary of what she saw as "the lameness of autobiography"; her brief essay "Thoughts on Autobiography from an Abandoned Autobiography" begins:

> I have been aware, as I write this autobiography, of a feeling of boredom with the project. My efforts to make what I write interesting seem pitiful. My hands are tied, I feel. I cannot write about myself as I wrote about the people I have written about as a journalist. To these people I have been a kind of amanuensis: they have dictated their stories to me and I have retold them. They have posed for me and I have drawn their portraits. No one is dictating to me now. . . .
>
> Memory is not a journalist's tool. Memory glimmers and hints, but shows nothing sharply or clearly. Memory does not narrate or render character. Memory has no regard for the reader. If an autobiography is to be even minimally readable, the autobiographer

must step in and subdue memory's autism, its passion
for the tedious.

The autobiography she refers to was duly abandoned. But
over time she found a different, characteristically oblique way
in. The snatches of autobiography that emerge in this pres-
ent book creep in around the edges of other people's lives. To
be sure, there are episodes and passages of a straightforwardly
autobiographical nature: recollections of events, remembered
feelings. But more than anything, we are made aware of little
Jana—of teenaged Jan—indirectly: as the observing sensibil-
ity whose impressions of the people in the faded photographs
form the narrative of this book. The problem of autobiog-
raphy's tediousness dissolves because we are looking not at
the self lurking behind the camera lens, but out through the
viewfinder with her: a characteristically elegant solution. Still
pictures.

Sheffield, Massachusetts
February 2022